IMAGES
of America

SUMMIT HILL

On the cover: **JUNIOR FIRE COMPANY.** This is the junior fire company in front of the firehouse during old home week on September 2, 1912. The idea of old home week turned into a celebration where people who grew up in town but moved away were invited to come home and visit the old homesteads and family and friends. (Courtesy of Summit Hill Historical Society.)

IMAGES
of America

SUMMIT HILL

Lee Mantz

ARCADIA
PUBLISHING

Published by Arcadia Publishing
Charleston SC, Chicago IL, Portsmouth NH, San Francisco CA

Printed in the United States of America

Library of Congress Control Number: 2008942246

For all general information contact Arcadia Publishing at:
Telephone 843-853-2070
Fax 843-853-0044
E-mail sales@arcadiapublishing.com
For customer service and orders:
Toll-Free 1-888-313-2665

Visit us on the Internet at www.arcadiapublishing.com

*Dedicated in memory of my friend Robert Fritzinger
and to my dad, Lyle Mantz. You will be forever in my heart.*

CONTENTS

ACKNOWLEDGMENTS

I would like to extend my appreciation to the Summit Hill Historical Society and Maxine Vermillion, curator of the museum, for use of many of the photographs in this book and access to the museum. I would also like to thank all the people who donated to the museum, because without them neither the museum nor this book would have been possible. I would also like to thank Diane Temples for her help with the history of the Presbyterian church and John Drury, Joe Slakoper, and Craig Walters for the use of their photographs. A special thanks to my brother Lyle Mantz and his wife, Andrea, for giving me access to the St. Paul's Reformed Church history and helping get the clearest images for a few of the pictures. Last but not the least, to my daughter Kassandra who has put up with me over the past several months while working on this book, thank you for your love and support. Unless otherwise indicated, the images are from the historical society or my personal collection.

INTRODUCTION

Summit Hill is a town that was founded due to the discovery of coal. It was in 1791 that Philip Ginder, while hunting on Sharp Mountain, found a black stone. He heard about a stone coal that burned and wondered if it was what he had found. Ginder took his find to Col. Jacob Weiss at Fort Allen, which is now Weissport. The stone he found was taken to Philadelphia by Weiss and shown to several people, including Michael Hillegas and Charles Cist, who were satisfied that this discovery was anthracite coal. In 1793, Weiss, Hillegas, and Cist formed the Lehigh Coal Mine Company. That year, Pennsylvania sold 10,000 acres of land to the company, which was located between what are now the towns of Mauch Chunk and Tamaqua. Getting the coal was easy, but getting it to an area where it could be marketed was impossible. In 1818, three men, Josiah White, Erskine Hazard, and George Hauto, leased the land from the Lehigh Coal Mine Company, and the process of mining and delivering coal began in earnest. The group's first goal was improving the Lehigh River and making it more passable for shipping. They needed permission from the state legislature and, although it was granted, the state called the idea impractical. From this, the Lehigh Navigation Company was born to set out to improve the Lehigh River. Two years later, White and Hazard combined the coal company and the navigation company because each one relied on the other for survival. The Lehigh Coal and Navigation Company was incorporated in 1822. But it was in 1820 that the first shipment of 365 tons of coal made its way to Philadelphia through the Lehigh Canals and Delaware River. Coal was very scarce because there was a boycott on English coal stemming from the War of 1812, and this first shipment, according to historian Alfred Chandler, proved to be the beginning of the Industrial Revolution.

It was during these early years of the mining industry that people started building in the area. Old state records show that a family built the first house on top of Sharp Mountain in 1800 when it was known as the "old mines." It is not known who the family was or what made them decide to build there, but they became known as the first "Summit Hillers." In 1826, there were five log cabins built, including the first two-story house, owned by James Lehman, the company boss. In 1837, the Lehigh Coal and Navigation Company started building houses for its employees, and Summit Hill began to look like a town. In 1846, the company began selling lots to individuals. Some of the first landowners were J. Edward Barnes, Nathan Patterson, D. D. Brodhead, Merritt Abbott, Jacob Minnick, Charles Hoffman, James Denton, and Daniel Minnick. Many of these men and others that followed built the first businesses in town. In the early 1850s, they included the Eagle Hotel, Steve Minnick's General Store, Abbott and Lockhart's Foundry, and the armory. By the mid-1870s, the town was booming, and many needs were required. The charter

for the Diligence Fire Company was drawn, streetlights were installed, a sewerage system was put in place, and the water company was incorporated. In 1889, after being part of Mauch Chuck Township, Summit Hill became incorporated on January 14 as a borough.

The most famous attraction of the town was the Switchback Gravity Railroad. It was originally built in 1827 to haul coal from the mines in Summit Hill to the canals in Mauch Chunk on a one-way nine-mile trip. By the mid-1840s, there was a need for a return track for the empty coal cars because of the amount of coal being taken from the mines. In 1845, the back track was completed along with the addition of two inclined planes, Mount Pisgah in Mauch Chunk and Mount Jefferson near Summit Hill, on the 18-mile circuit. The Switchback was no longer needed for coal-hauling purposes after 1872, and it was strictly used for pleasure rides. It became one of the most famous tourist attractions in the country at that time, second only to Niagara Falls. Because of the railroad's fame and with it running through Summit Hill, that brought as many as 30,000 visitors to the town in a season. Some famous people rode the Switchback, including Ulysses S. Grant in 1876, five years before being elected president, and first lady Frances Folsom Cleveland in May 1888. It was in June 1899 that Thomas Edison visited, and when asked if the railroad should be electrified, he answered it was fine the way it was. What is special about the Switchback is that it is now known as the first roller coaster. A man by the name of La Marcus Thompson rode it in the late 1800s. After nearly having a nervous breakdown in the early 1880s, Thompson, influenced by his ride on the Switchback, came to invent the first amusement roller coaster, the Gravity Pleasure Switchback Railway at Coney Island in Brooklyn.

A short walk to the west end of town provided the most curious tourist attraction of Summit Hill, the burning mines. The fire began around 1859. By the time it was found, most of the timber and much of the loose coal was burning. Many attempts were made to put out the fire, from flooding the mine with water to boring holes and filling them with culm and water, but nothing worked. The fire burned for almost 100 years, and visitors marveled at the sight of steam rising out of the ground during the day and the soft orange glow in the cracks at night. Because the ground stayed warm all the time, the area was known as a "carpet field" because the grass stayed green year-round.

The history of Summit Hill will live forever in the pictures and souvenirs from a bygone era. One can only imagine what life was like to ride the Switchback Gravity Railroad, to ride a trolley through town, and have almost everything needed within the town limits. The buildings and the tracks may be gone, but the history lives on.

One

SUMMIT HILL

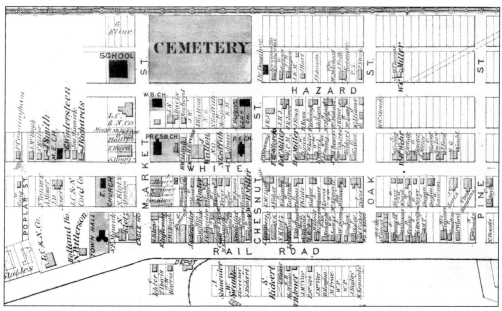

SUMMIT HILL MAP, 1875. This map of town is from the *Atlas of Carbon County* from F. W. Beers and Company. Most of the town was centered between Poplar Street (now Walnut Street) and Pine Street. Rail Road Street was also known as Front Street, and it was in May 1929 that it was renamed Ludlow Street.

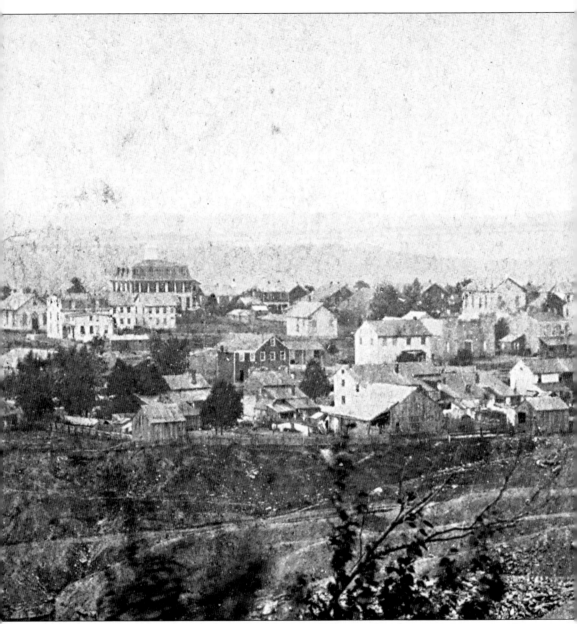

SUMMIT HILL, 1875. This photograph of Summit Hill was taken by stereoscopic artist James Zellner of Mauch Chunk. He ran his studio on the corner of Race and Susquehanna Streets above a shoe shop for nearly 25 years. This is one of the earliest-known pictures and shows the town with many of its original buildings. The large structure on the left is the Lincoln School

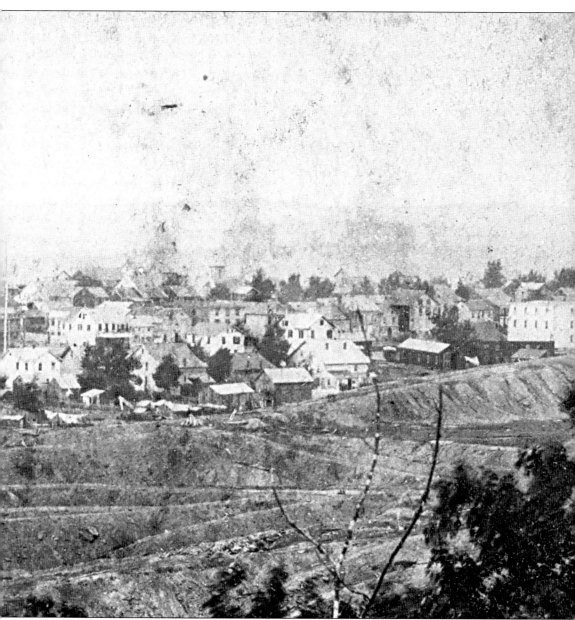

building. In the middle is the armory, the Eagle Hotel, and centered between them is the first Presbyterian church building. At right is the Switchback Gravity Railroad station, with a car sitting at the turn possibly waiting for passengers on its return trip to Mauch Chunk.

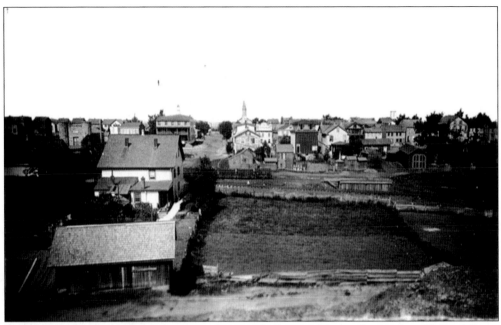

TOWN CENTER, MID-1880S. This view of town is looking up Market Street when Holland Street was nothing more than a railroad right-of-way. The steeple is from the Presbyterian church, with the armory and the Eagle Hotel seen to the left. A Switchback Gravity Railroad car is seen leaving the station on its way back to Mauch Chunk. (Courtesy of John Drury, Mauch Chunk Museum.)

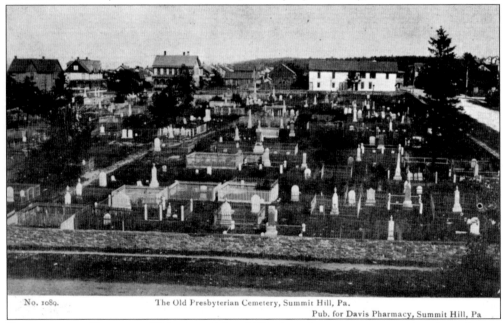

No. 1089. The Old Presbyterian Cemetery, Summit Hill, Pa.

Pub. for Davis Pharmacy, Summit Hill, Pa

PRESBYTERIAN CEMETERY. This view of the old Presbyterian cemetery was taken from the top of the Lincoln School building. This plot of land was given by the Lehigh Coal and Navigation Company on April 15, 1850, for use as a cemetery. The last burial was that of Albert Butterworth in 1962. After being neglected for many years, the church turned the deed over to the town, and it became Memorial Park in 1974.

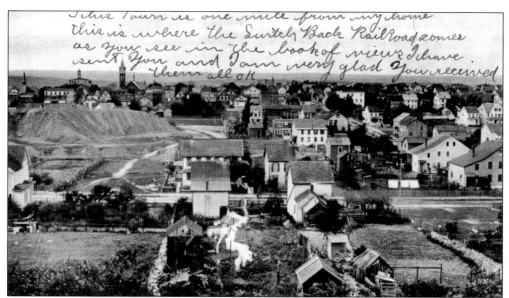

This Town is one mile from my home this is where the Switch Back Railroad comes as you see in the book of views I have sent you and I am very glad you received them all ok

BIRD'S-EYE VIEWS. These views of the town are from about 1905. Around this time, the population of Summit Hill, which included the election districts of Hackelbernie, Bloomingdale (White Bear), Andrewsville (No. 6), and Jamestown (No. 5), totaled over 3,000 residents. In January 1889, the town was incorporated as a borough. Up until that point, it was a part of Mauch Chunk Township. A month later, residents elected their first burgess (mayor), Joseph Richards. The first councilmen were James McCready, Samuel McNeal, Samuel Richert, William Schneider, Neal Boyle, and Edward Riley. The first tax collector was Samuel Derby.

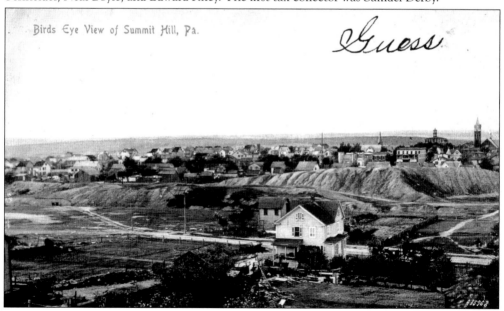

Birds Eye View of Summit Hill, Pa.

Guess

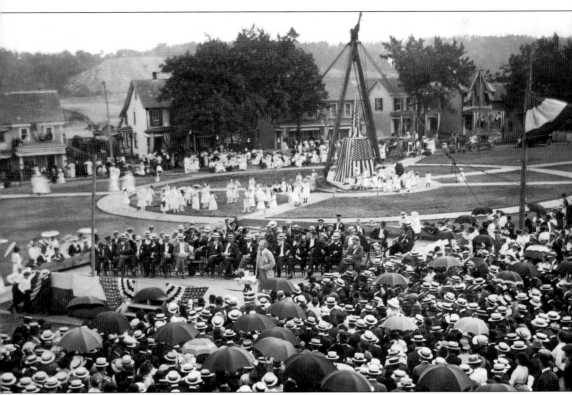

DEDICATION OF CIVIL WAR MONUMENT. On July 4, 1914, the Civil War monument was dedicated, with over 5,000 people in attendance. There were three sections to be delivered for the event, but only the base and the soldier arrived in time. White pigeons were placed under the lower bunting, and when it was lifted, the pigeons flew out and circled the monument. The total cost of the monument was $10,000, which was a large sum at the time. It was over 30 feet in height. The figure is a federal color bearer done in bronze by Jules Berchem of Chicago. It was Harry Miller who hitched up 16 mine mules to a heavy wagon and hauled the monument from the Lehigh and New England Railroad, near St. Joseph's church, to the park.

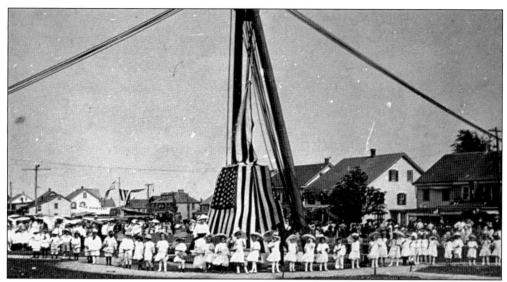

SCHOOLCHILDREN. Ida Kutz and her kindergarten class pose in front of the monument. A five-division parade was held that day, with Burgess Samuel Wehr being the chief marshal and E. T. McCready the master of ceremonies. Also involved in the festivities were Rev. H. I. Nicholas, J. J. Bevan, and Civil War veteran Judge Charles Brunn. Capt. Steve Minnick did the unveiling.

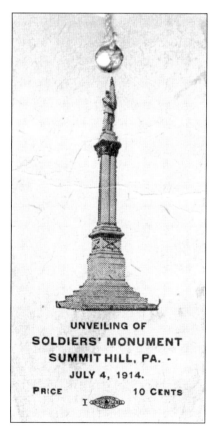

UNVEILING OF
SOLDIERS' MONUMENT
SUMMIT HILL, PA. -
JULY 4, 1914.
PRICE 10 CENTS

UNVEILING TICKET. Donations were not only sought in Summit Hill but also in other local towns. A letter from the Monument Fund Association from August 1913 stated, "An appeal is being sent to the organizations of Summit Hill, Lansford, Coal Dale, and Nesquehoning for a donation to the Soldier's Monument Fund. It is our aim to unveil the monument next Memorial Day and we want it to represent the patriotic spirit of our four towns."

15

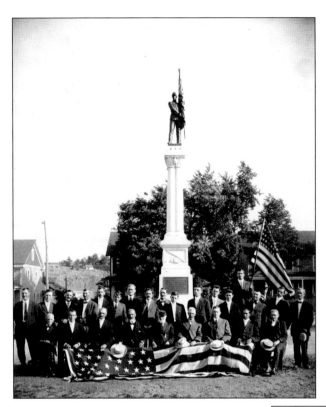

PARK DEDICATION. On September 5, 1914, the park was officially dedicated to the town after a parade. E. T. McCready was the master of ceremonies. Attorney E. E. Scott presented it to the town, and then John McTague gave it the name of Ludlow Park in honor of Lehigh Coal and Navigation Company's vice president Edwin Ludlow, who gave the land to make it possible.

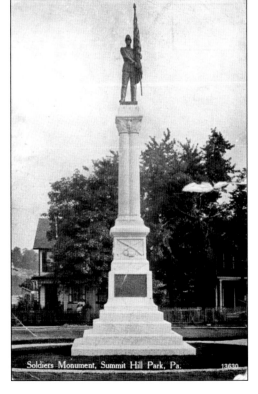

COMPLETED MONUMENT. By the time the park dedication occurred, the Civil War monument was completed with all three sections. The monument's plaque reads, "To all defenders of the Union from Summit Hill Panther Valley and to their parents and wives. Erected by the citizens of Summit Hill and Panther Valley."

16

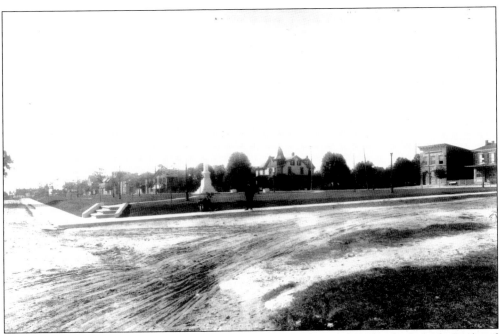

LUDLOW PARK, 1915. Most of the landscaping of the park was done by the Lehigh Coal and Navigation Company engineer. The lamps in the park were run by gas. The cannons were donated by the J. F. Breslin Post No. 77 in October 1918. The flagpole by the Civil War monument was replaced in October 1915, and the other at the west end of the park was placed by the Italian-American Club on October 12, 1918. A monument to World War I veterans was dedicated on November 22, 1922, on the west side. It was erected by the Summit Hill schools from pennies collected by the students.

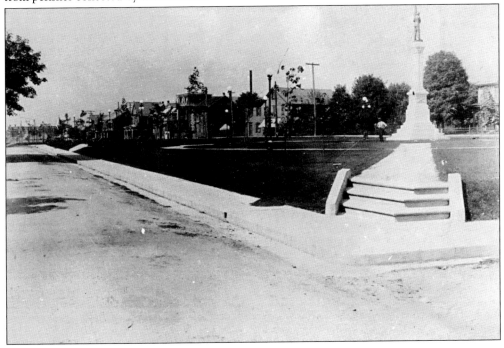

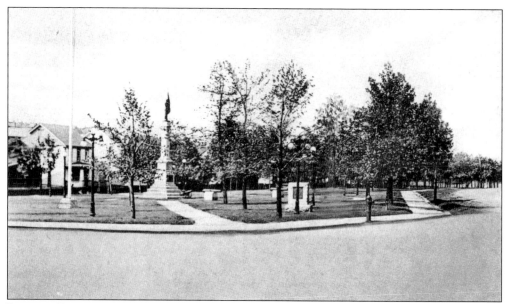

LUDLOW PARK, 1930s. A monument dedicated to those who served in the Spanish-American War was dedicated on September 7, 1936, and was made possible by the ladies auxiliary of the United Spanish War Veterans. The inscribed tablet was cast from metal recovered from the USS *Maine*. At the far west end of the park, a monument was dedicated in 1941 for the 150th anniversary of Philip Ginder discovering coal.

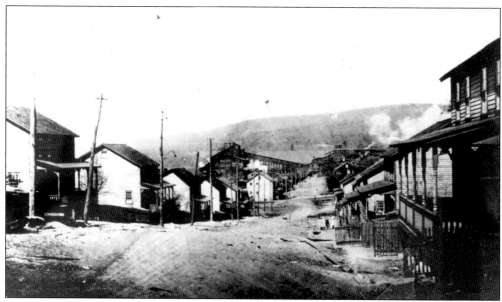

ANDREWSVILLE. The patch town of Andrewsville was built around the No. 6 mine tunnel and breaker. Located on the east side of Lansford, Andrewsville was part of the Summit Hill voting district. In 1880, almost 700 people lived in the Andrewsville and Jamestown settlements. Jamestown was another patch town that was built around the No. 5 tunnel, just south of Andrewsville.

Two

A Stroll
through Town

"But I am Coming Queek." Many businesses utilized plain postcards and stamped "Summit Hill" on them to personalize the town. This card was part of a series that depicted Quakers carrying a banner. It was sent by William Lusch in 1913, telling his brother about his trip to Coney Island.

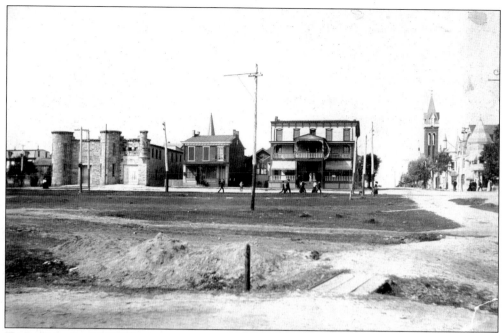

TOWN CENTER, 1900. This is a great view of the center of town around 1900, taken from Holland Street. All three buildings in the view were constructed in the early 1850s, with Abram Harris erecting the Eagle Hotel on the corner and the house next to it in 1850. The Presbyterian church building in the background was only a couple years old when this photograph was taken.

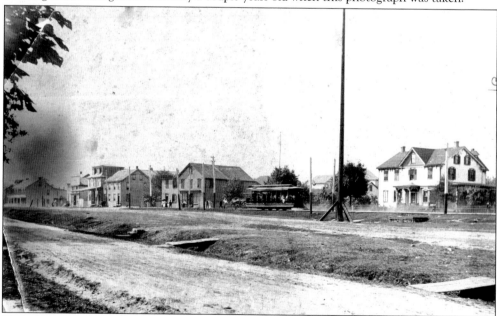

WEST FRONT STREET, 1900. A trolley car rolls into town on what appears to be a busy day, with people dressed in their Sunday best. The building near the trolley car was the store owned by Henry Williamson where Morgan Powell walked out of on December 2, 1871, and was shot by a then-unknown assailant. The company gave GAR Connor Post No. 177 permission to place a flagpole on a small plot along Holland Street. It was known as the liberty pole.

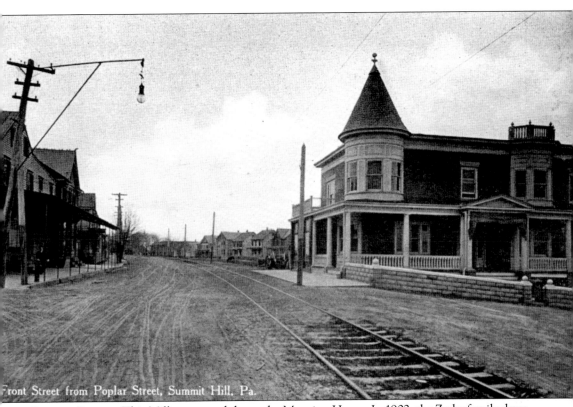

Front Street from Poplar Street, Summit Hill, Pa.

POPLAR STREET. This Millar postcard shows the Mansion House. In 1902, the Zerby family drew up plans for one of the finest buildings in town. The walls were made of brick four layers deep, and all the lumber was hand cut. J. E. Zerby was a bottler of whiskey and beer, which was done in the basement. The first floor was used for storage. In 1920, Guida Lisella bought the building and continued to bottle alcoholic beverages after Prohibition. After the 18th Amendment was ratified, the Lisella family went in to the furniture business upstairs. In the basement, rumor has it that a speakeasy was run and some of the finest beer and whiskey was made. Across the street are company buildings and the Rising Sun Hotel, which was once owned by Thomas Fisher, one of the Molly Maguires accused of killing Powell.

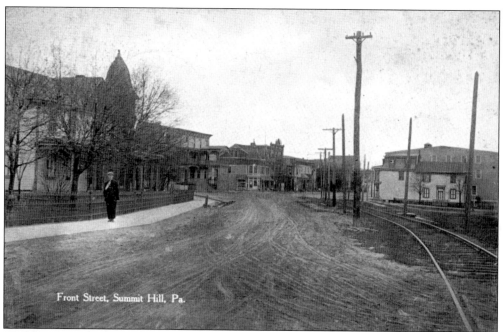

Front Street, Summit Hill, Pa.

WALNUT STREET. This view is from Walnut Street. The building on the left later became the convent for St. Joseph's church and school. The trolley tracks are from the Tamaqua and Lansford Street Railway Company. This is one of the few views from the golden age of postcards in which the person in the picture is known. The gentleman is Summit Hill resident Hugh Doughtery.

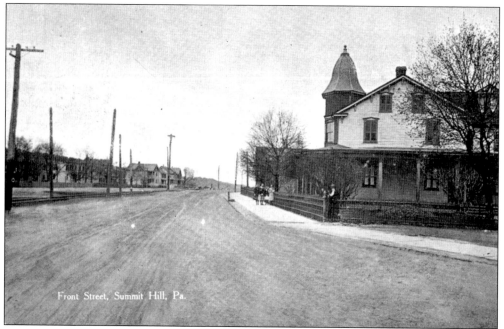

Front Street, Summit Hill, Pa.

FRONT STREET, LOOKING WEST. On an old town map, the owner of this house was listed as Susan McCready. Several of the houses on West Holland Street can be seen on this postcard. Years before it was cleared for the park, the company used the land for stables and shops.

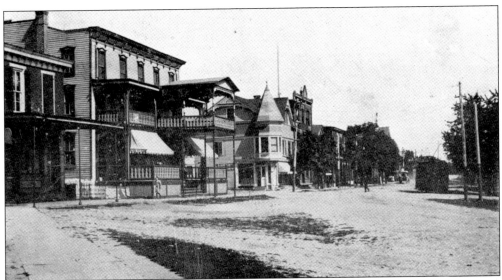

EAGLE HOTEL. It was in 1846 that the company began selling lots to individuals and the town started taking shape. In 1850, Abram Harris purchased land for the Eagle Hotel. The hotel was constructed by George Hunsicker and Pius Schweibinz of Mauch Chunk. It quickly became one of the town favorites for locals and tourists. The biggest social event of the year was the annual mule drivers' ball. In 1886, James and Ellen Sweeney bought the hotel and owned it for the next 20 years. Frank Kershner bought it for $16,000 in 1906. For nearly 70 years, the hotel was the sight for boxing matches, basketball games, dances, roller-skating, and movies. It was razed in the early 1920s to make way for the Mauch Chunk Silk Company building.

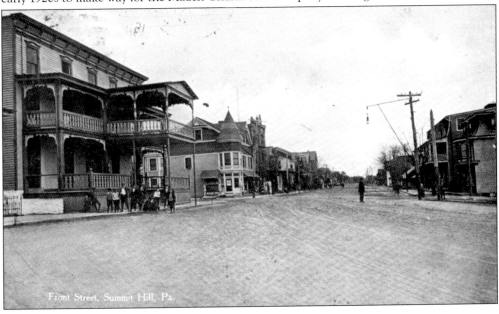

Front Street, Summit Hill, Pa.

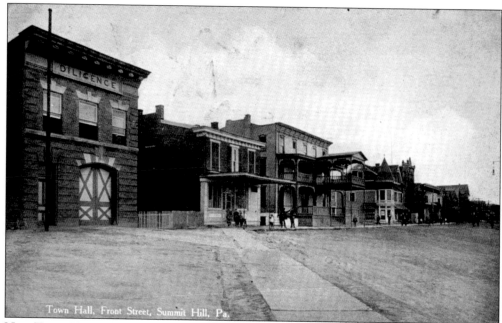

Town Hall, Front Street, Summit Hill, Pa.

NEW TOWN HALL. When this picture was taken, the town hall was but a few months old. After the armory burned down in March 1908, a new town hall was needed. Moses Neyer, Edward Miley, and Michael Bonner formed the new building committee. Andrew Breslin was hired to build a new town hall that would house the fire department and the town council. The work was completed by the end of the year.

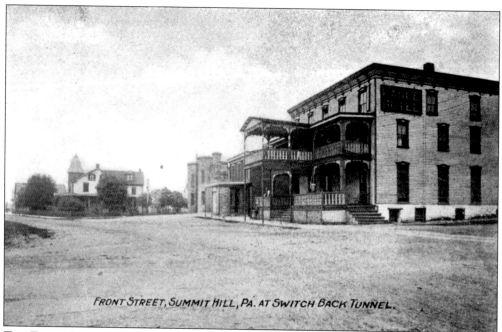

FRONT STREET, SUMMIT HILL, PA. AT SWITCH BACK TUNNEL.

THE EAGLE HOTEL AND ARMORY. Taken from Market Street in 1906, this might be one of the only postcard views showing the armory still standing. The reference in the caption to the "Switch Back Tunnel" is to the station, which was in the middle of the next block.

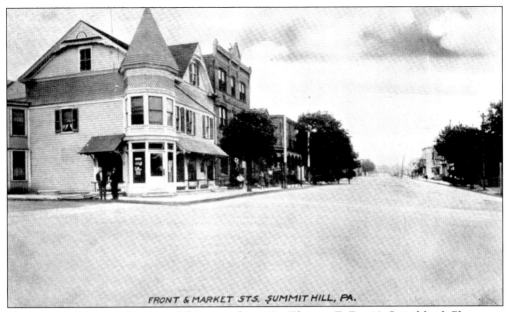

FRONT & MARKET STS. SUMMIT HILL, PA.

FRONT AND MARKET STREETS. This view shows Dr. Thomas E. Davis's Switchback Pharmacy with the Switchback Hotel next door. The hotel was owned by O. E. Dermott at the time, and in 1908, he applied for a license to show movies. Other merchants on this block included Joe Arner, Bert Lusch, and A. Schneider.

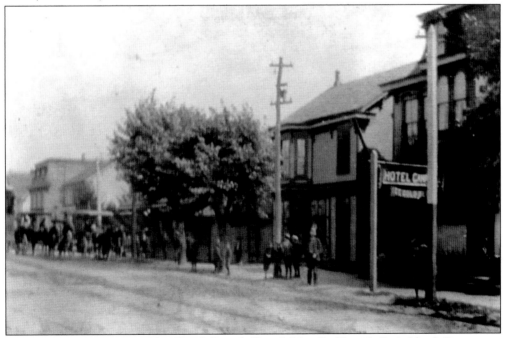

DEPOT AND BUSINESSES. The Hotel Campbell and John R. Harris's Switchback Restaurant were favorite spots after arriving at the station. Tourists also had the option of waiting for the trolley to take them to Lansford. Neal Campbell ran the Switchback Cafe from the hotel and served beer and whiskeys. Harris's restaurant had a little of everything, from ice cream to coal souvenirs. Note the line of people boarding the trolley.

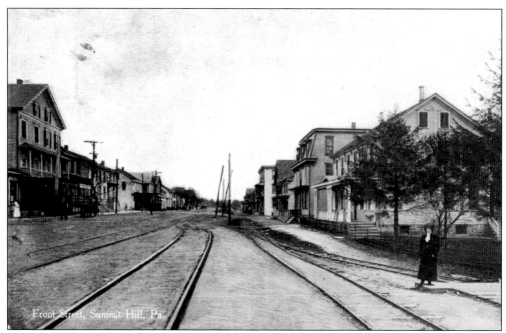

FRONT OF DEPOT STATION. This picture was taken in front of the Switchback Gravity Railroad station, showing the trolley tracks to the left. By the time this picture was taken in 1908, a slow decline began for the railroad. The automobile and other new tourist attractions, such as Flagstaff, took away riders.

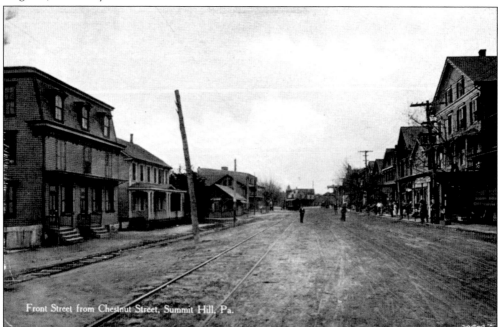

FROM CHESTNUT STREET, LOOKING WEST. This postcard view shows a trolley heading into town. The buildings on the left were owned by William Swank and Anthony Schneider, followed by the Switchback station. The trees are bare, and the streets are busy even though it is in the off-season of tourism.

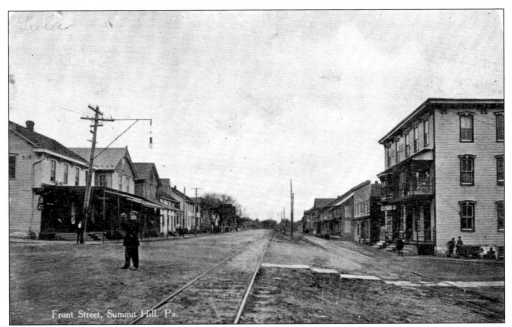

FROM CHESTNUT STREET, 1908. This view shows the first block of East Front Street. On the back of the postcard is written, "The house on the corner is Nolan's Music Store." It later became home to the Summit Hill Trust Company in 1920. The building on the right was owned by Samuel Rickert. The Summit lodge of the Independent Order of Odd Fellows rented his hall. Next door was George Thomas's bakery.

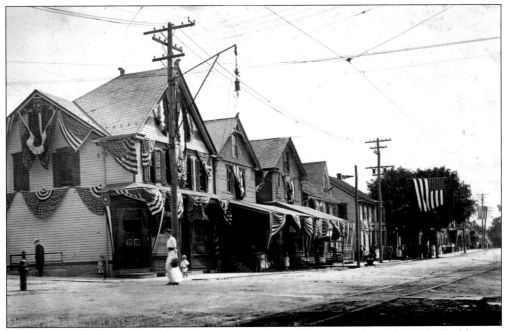

FROM CHESTNUT STREET, 1912. This picture is from old home week in 1912. The building on the corner is James Cannon's bar. The building two doors down was the M. J. Stoudt and Son General Store. It is now home of the Summit Hill Historical Society Museum.

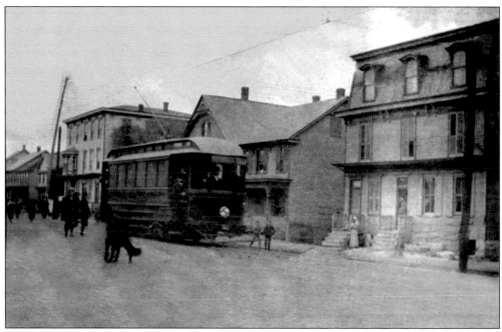

FIRST TROLLEY RUN. The first trolley to go through town was in May 1897. That year, the Tamaqua and Lansford Street Railway Company was given the right to run cars in town between 5:00 a.m. and 11:00 p.m. The trolley ran connecting times with the Switchback Gravity Railroad station in town and the Central Railroad of New Jersey depot in Lansford.

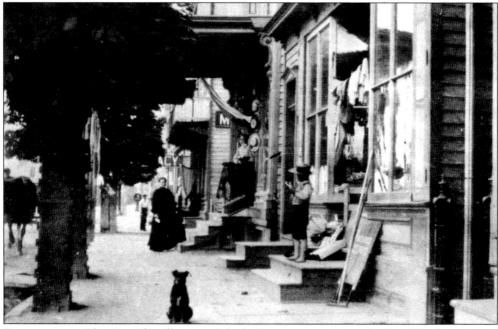

STOREFRONTS. This is a sidewalk view of the businesses across from the Switchback station in June 1897, looking toward the Switchback Pharmacy. Businesses in the summer were kept busy with the constant flow of tourists arriving on the railroad. Wooden barriers were put around trees to stop the horses from chewing the bark off.

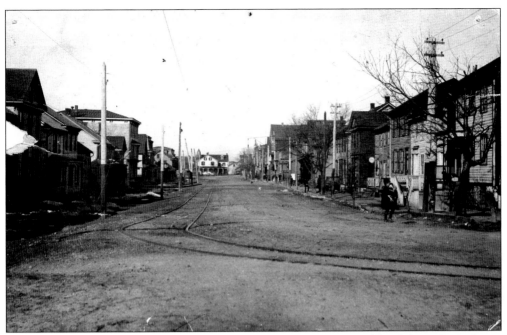

FROM OAK STREET. The trolley tracks take a turn off Oak Street and head down Front Street in this late-winter scene. The town was quiet during the off-season months of the Switchback Gravity Railroad. The trees are bare, and the merchants are resting up for the upcoming tourist season.

EAST FRONT STREET. This is a view of East Front Street near Oak Street. The three-story building in the background was the Independent Order of Odd Fellows building, which also housed Reick's Pharmacy, and the building on the corner was a butcher shop run by Will Mantz. This picture was taken around 1915.

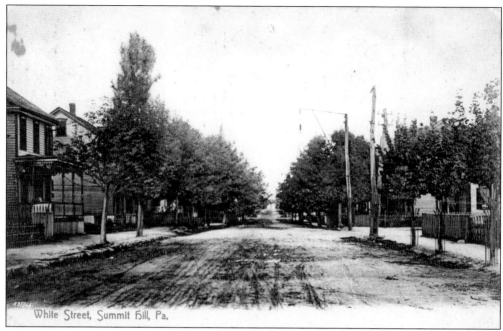

White Street, Summit Hill, Pa.

WEST WHITE STREET. This is West White Street between Poplar and Walnuts Streets in 1905. All of the houses were residential, and some of the owners were Peter, Frank, and J. F. O'Donnell, John Harkins, Hugh Daly, and Edward Kennedy. The tree-lined, rutted dirt streets are a stark contrast to today's view.

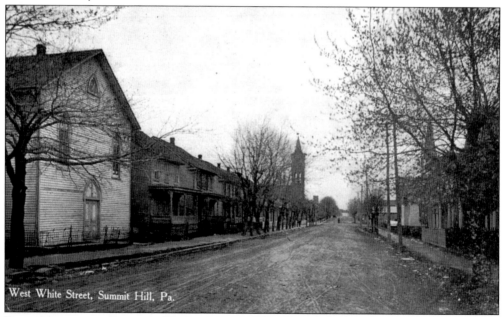

West White Street, Summit Hill, Pa.

FIRST METHODIST CHURCH. This is a view of the first Methodist church building on West White Street. In 1872, the one-story church was dedicated. Then in 1888, the building was raised and a stone wall was built under it. An addition was put on the west side of the church in 1893. When the congregation erected a new building on East White Street, this one was sold to the Polish National Catholics in 1930.

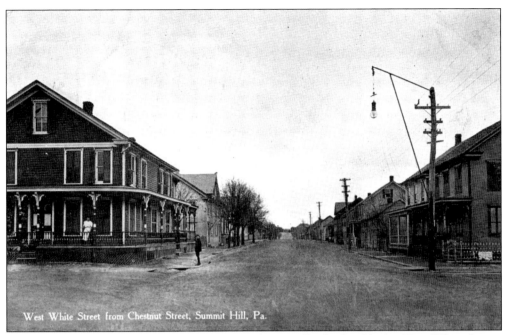

West White Street from Chestnut Street, Summit Hill, Pa.

WHITE AND CHESTNUT STREETS. This postcard is actually the first block of East White Street, looking east toward the cemeteries. Some of the families that owned houses on the block were the Arners, Goulds, and Dugans. An old globe-type electric streetlamp in the view had power supplied by the Panther Valley Electric Light, Heat and Power Company.

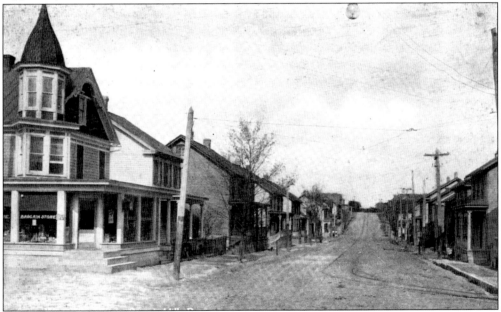

WHITE AND OAK STREETS. The business on the corner was Leslie's Bargain Store. In later years, it became Harry Miller's funeral home. The trolley tracks are seen heading up to the cemeteries. The trolley cars occasionally served as funeral cars for years. The east end of Summit Hill was the home of eight different cemeteries. Lansford and Coaldale had no ground suitable for burial since most of the area was being mined.

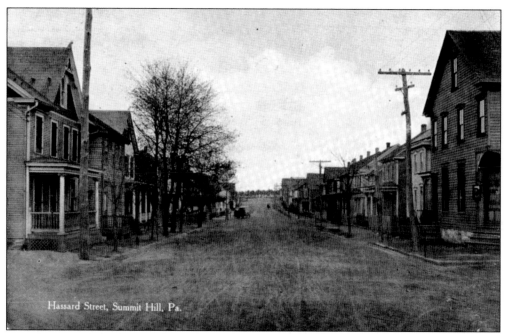

Hassard Street, Summit Hill, Pa.

HASSARD STREET. The correct spelling should be Hazard Street, named after Erskin Hazard, one of the founders of the Lehigh Coal and Navigation Company. The cemetery at the end of Hazard Street belongs to St. Joseph's church.

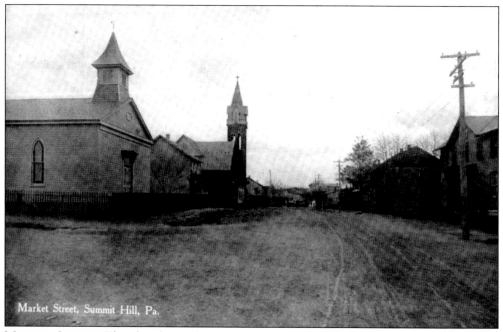

Market Street, Summit Hill, Pa.

MARKET STREET. The church on the near corner was the Welsh Baptist Church. In 1852, Rev. David Evans and a small congregation built their church on the corner of Hazard and Market Streets. The building did not have any baptismal fonts, so parishioners were baptized in the breaker cistern.

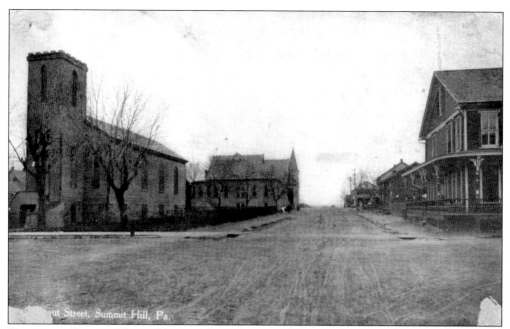

CHESTNUT STREET. This is Chestnut Street between White and Hazard Streets. The church of St. Philip's Episcopal and St. Paul's German Reformed, in the background, along with the two churches on Market Street formed what was called "holy square," which was even featured in *Ripley's Believe It or Not.*

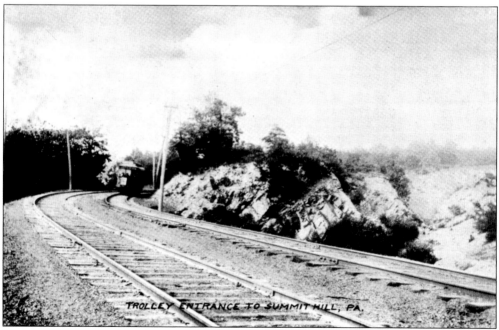

TROLLEY ENTRANCE. The far west end of town where Front and White Streets met at St. Joseph's church was called Coal Street. The Lehigh and New England Railroad tracks came from the mining areas in Andrewsville and connected to the mines in Summit Hill.

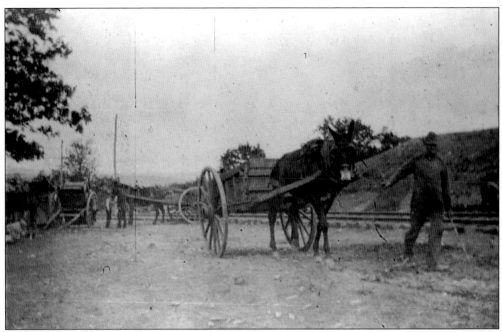

COAL STREET. These views are of Coal Street, which is the last side street on the west end of town by St. Joseph's church. The men here are working on clearing the way to lay the trolley tracks from the Tamaqua and Lansford Street Railway Company that will pass through town on Front Street. These pictures were taken in early 1897 when work had just begun. The trolley line ran parallel to the Lehigh and New England Railroad tracks that came from the No. 5 and No. 6 mines in the Andrewsville area to Summit Hill.

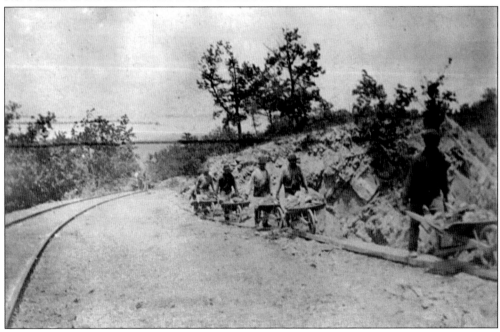

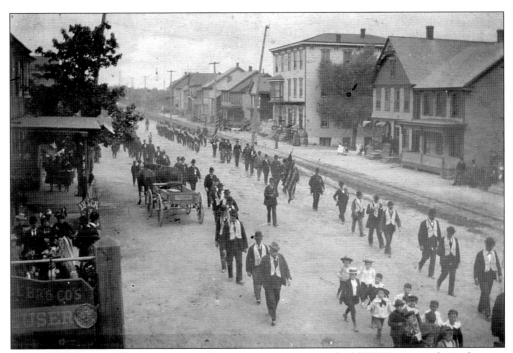

THE 1897 PARADE. This photograph from Joe Arner was marked 1897. It was early in the year since the trolley tracks have not been laid out. It seems the town was always having some kind of social event or parade. Summit Hill became known for being a social spot for the coal regions.

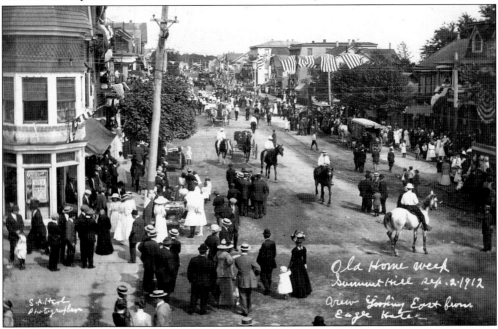

OLD HOME WEEK. This was the grand parade held on September 2, 1912. The picture, taken by S. A. Herb, was shot from the balcony of the Eagle Hotel. A trolley is seen in the background making an attempt to leave town. Old home week seemed to coincide with the Labor Day holiday.

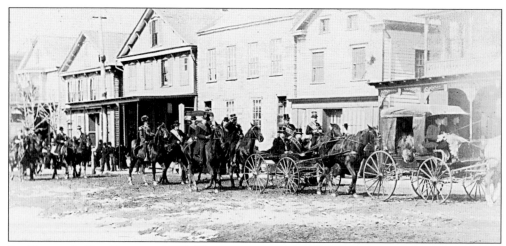

ST. PATRICK'S DAY PARADE, 1895. This picture was taken by town photographer C. H. Stoudt in 1895. The parade shown here is from St. Patrick's Day, taken in the vicinity of the Switchback Gravity Railroad station. Stoudt, also spelled Staudt on his early prints, did portraits of many locals, including babies and scenery.

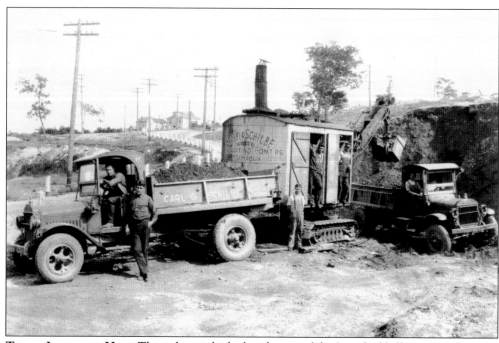

TOP OF LANSFORD HILL. This is how it looked at the top of the Lansford hill in 1927, when the main road though town was Chestnut Street. Lehigh and North Streets were not even on the map yet. The men here are from Krosby and Schilbe Excavating in Tamaqua and are filling a mine breach.

Three

BUSINESSES

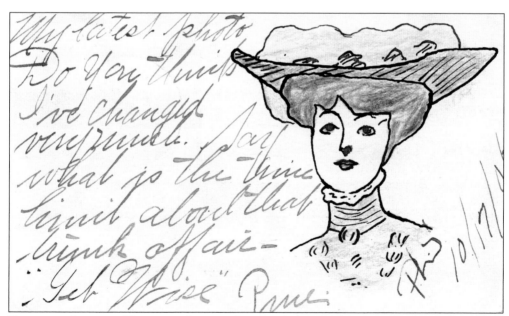

PRUDENCE SINYARD. This unusual postcard was mailed in 1906. It is a self-portrait of Prudence Sinyard in which she asks her friend, "My latest photo. Do you think I've changed very much?" Picture postcards were just making their way into many of the souvenir racks in town at this time, and usually cameras were only owned by people who did photography as their livelihood.

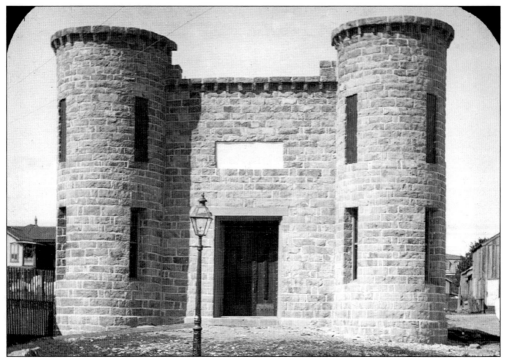

ARMORY, 1880s. This picture was taken from a lantern slide, dating from the 1880s. The armory was dedicated on August 25, 1854, and the grand annual ball was held, with tickets being sold at $2 a piece. The money raised from the ticket sales, along with shares of stock sold to individuals, paid for the building.

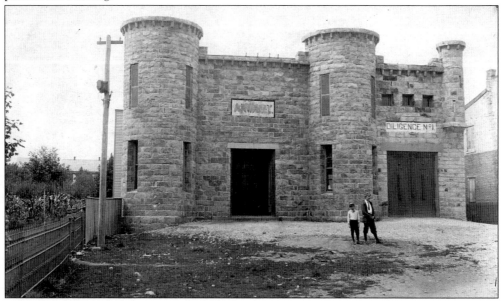

ARMORY, 1890s. The armory was built under the guidance of Merritt Abbott and Capt. A. J. Wintersteen. It was home of the Carbon Guards until after the Civil War, when the company was disbanded. The walls were made of stone, and the appearance resembled a French bastille. The armory was purchased by the town in 1890, and a few years later, the firehouse was added.

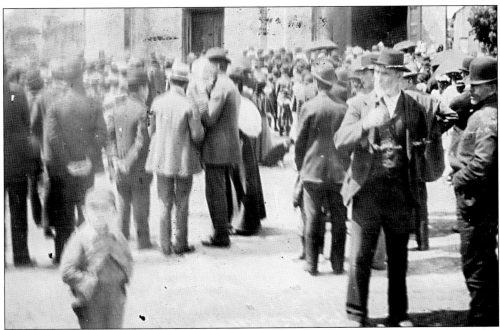

ARMORY, EARLY 1900S. The building was used as a meeting place for the Summit Hill Town Council and the Diligence Fire Company, and it was also the site for dances and festivals. In the late morning of March 25, 1908, it is suspected that an overheated stove in the ticket office started a fire. According to an article in the *Mauch Chunk Coal Gazette*, the fire had gained strength due to a stiff wind. After the fire company removed its apparatus, the men quickly began hosing the fire down. The Lansford Fire Department was called, as the nearby buildings owned by S. F. Minnick and James McCready were threatened. When the fire was extinguished, nothing remained but the stone walls. The loss was estimated at $10,000. The stones were removed from the site and used in the foundation of the Dime Bank in Lansford.

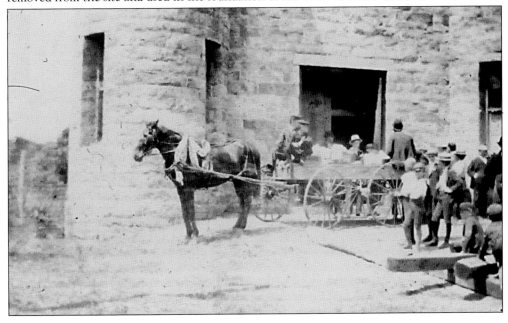

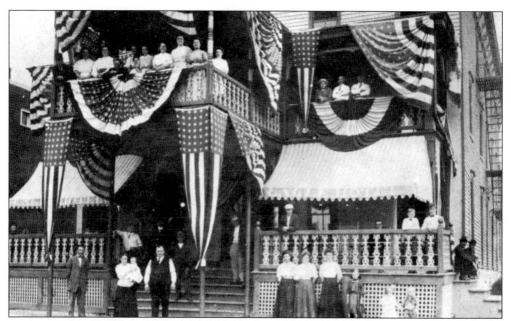

EAGLE HOTEL DURING OLD HOME WEEK. This is how the Eagle Hotel looked during old home week early in the second decade of the 20th century. The couple with the baby is Mr. and Mrs. Frank Kershner, owners of the establishment at the time. The ladies on the balcony are the waitresses for the dining hall. Years later, Frank Kershner died when he fell from a hayloft in his stable in White Bear.

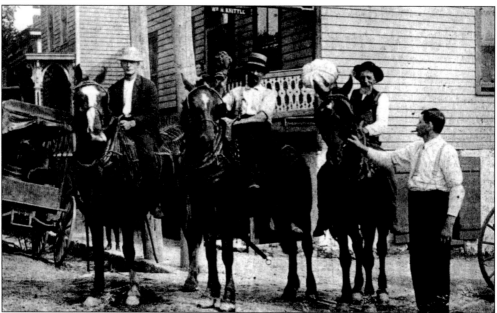

WASHINGTON HOTEL. This hotel was located on White Street across from the Presbyterian church. The man standing holding the bridal of the horse is William Knittle, owner of the property. The men on the horses are, from left to right, William Hamm, Edwin Fritz, and Reuben Nothstein. The Washington Hotel was destroyed by fire on April 2, 1929, with the probable cause being electrical in nature.

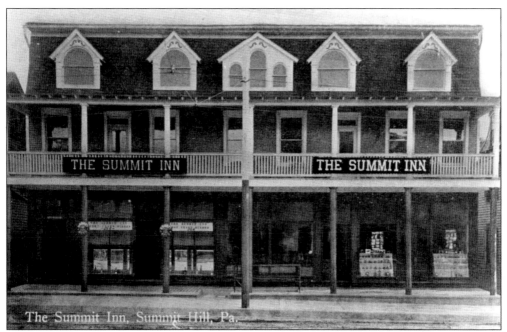

The Summit Inn, Summit Hill, Pa.

SUMMIT INN. The Summit Inn was built in 1908 by Dr. Thomas E. Davis, the owner of the Switchback Pharmacy. After that, it was owned by the Manconi family, who operated a grocery store on the first floor. Along side the store, Jack Boyle ran a restaurant. The upstairs was a garment factory for many years.

No. 407 — DRAWING FOR A PONY BY DANIEL MILLER Monday, Sept. 6, 1915. ..SUMMIT INN.. SUMMIT HILL, PA. TICKETS - 10 CTS. OR 3 FOR 25 CENTS

WIN A PONY. Yes, one could actually win a pony back in the day. Daniel Miller offered up a pony to be raffled off at the Summit Inn on Labor Day in 1915. Almost anything could be won in town during this time period, from livestock to automobiles. There was no record of the winner.

ARNER'S. This is a picture of Joe Arner's hardware store along Front Street, which he opened in 1885. Along with running a hardware store, Arner took many pictures of town that are in this book, and his family took the time to preserve many of his photographs and negatives.

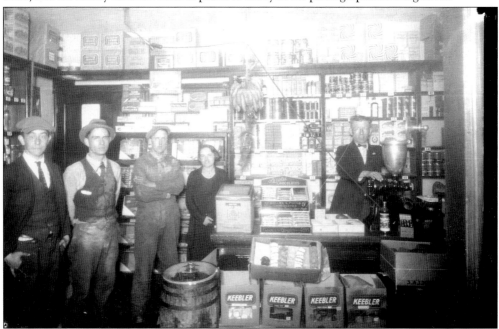

SHOPPING. Welcome to the inside of one of the town's general stores in the mid-1920s. It is unknown which store this picture was taken in. The counter has displays from the National Biscuit Company and Pirika Chocolates. The man on the right is about to use the new electric Hobart Coffee Grinder.

W. D. KELLAR. W. D. Kellar operated his general store on Front Street in the early 1900s. In the picture are Bella Betz, Sybelle Kellar, Rose Lill, W. D. Kellar, Claude Wehr, and the child is Wilbur Derby. Merchants often had free advertising handouts. Kellar's items were eight plates with floral designs on them.

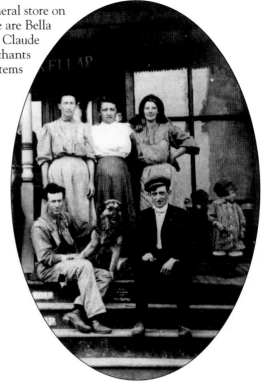

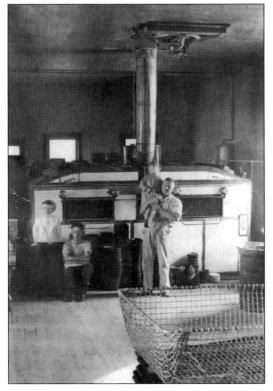

THOMAS'S BAKERY. George Thomas opened Thomas's bakery in 1905 when he bought Dougherty's bakery on East Front Street. Thomas operated the bakery until 1929, when he turned it into a bowling alley with two lanes. In the picture, he is holding his son John, and his daughter Margaret is on the far left. It is unknown who is sitting in front of the oven.

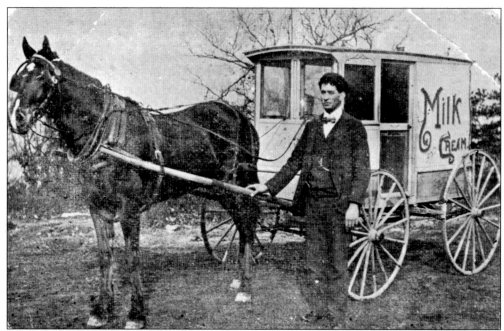

EDWARD REDLINE. Edward Redline was the milkman in the Bloomingdale section of town. In the 1890s, when it was still part of Mauch Chunk Township, the population was over 200 residents. The area was always known as White Bear because of the hotel at the bottom of the hill was named so.

WHITE BEAR HOTEL. The White Bear Hotel was built in 1846 by Levi Smith and Hannah Roth in Bloomingdale. It was built along a trail that was frequently used by farmers from Mahoning Valley to bring their produce to Summit Hill and Panther Valley. The trip took two days, so the farmers found it a convenient stop along the way. It was torn down in May 1970 to widen Route 902.

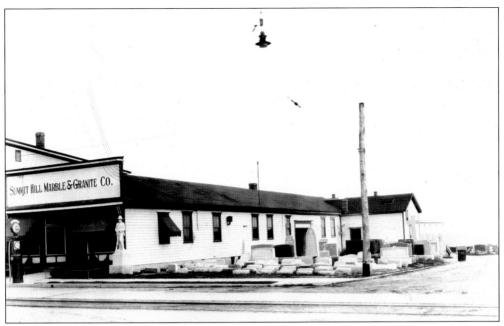

SUMMIT HILL MARBLE AND GRANITE. In the mid-1920s, Bronne Bruzgo Sr. opened Summit Hill Marble and Granite. What started as a small-scale company soon expanded and became one of the largest monument makers in the east. The doughboy in front of the building now resides in St. John Byzantine cemetery. (Courtesy of Craig Walters, Walters' Monument.)

The goods in this case contains only the best cane sugar. Certified harmless coloring. *No Coal-Tar Dyes.* Best of flavoring which contains NO ether. Filtered water.

——GUARANTEED BY——

P. J. O'DONNELL,

SUMMIT HILL, PENNA.

P. J. O'DONNELL. This is a crate label from the P. J. O'Donnell Bottling Company from the late 1800s. O'Donnell was one of the few bottlers that continued for many years. It later became O'Donnell Brothers when the sons took over the business. Many other bottlers came and went during this time, such as J. G. Mealey, John Matta, Peter Sofsky, and Paul Madak, to name a few.

45

W. SCHNEIDER,

~~~ DEALER IN ~~~

DRY GOODS, GROCERIES,

FANCY GOODS, NOTIONS

~~~ AND ~~~

GENERAL MERCHANDISE.

FRONT STREET,

SUMMIT HILL, PENN'A.

W. SCHNEIDER. Schneider's General Store was located across the street from the Switchback Gravity Railroad station. He was listed in the Carbon County business notices as "a dealer in dry goods, groceries, provisions, and Queensware." These types of advertisements were known as Victorian trade cards. Popular in the late 1800s, it was at the 1876 Philadelphia Centennial Exposition that the colorful trade cards made their debut. The cards were popular until the early 1900s, when newspapers became a cheaper and easier method for advertising. After the general store closed, the building was later used as a restaurant called Nick's.

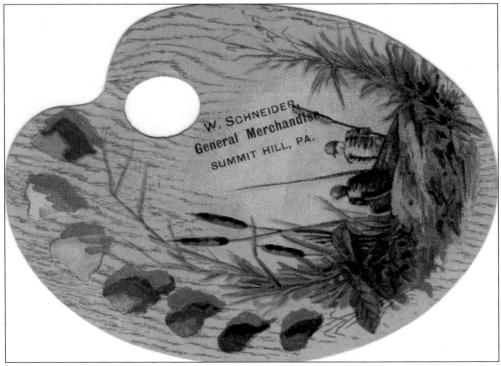

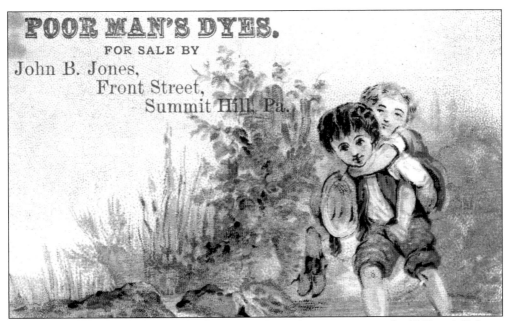

John B. Jones. John B. Jones was a druggist on Front Street in town and sold Kemp's Balsam, Kemp's Liver Pills, and Poor Man's Dyes. The earliest trade cards were only in black and white. It was in 1876 that cards were made with colorized lithography and became quite collectible. Businesses ordered in bulk and stamped their own company name on the card.

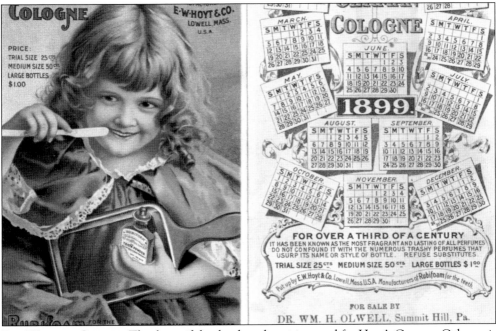

Dr. William Olwell. This beautiful calendar advertising card for Hoyt's German Cologne is from pharmacist Dr. William H. Clewell. The card was printed with a typo. Clewell recruited men for Pres. William McKinley's second call for volunteers in the Spanish-American War. About 125 men from Carbon County answered the call and were sworn in at the armory. Before they could finish training, the war ended, and none saw any action.

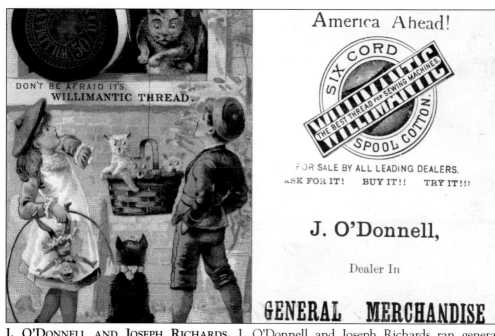

J. O'DONNELL AND JOSEPH RICHARDS. J. O'Donnell and Joseph Richards ran general merchandise stores in town. Richards specialized in selling boots and shoes. He later became the town's first burgess. Both of these 1880s trade cards advertise Willimantic Thread, which was described as "the best thread for sewing machines." The lithography on the O'Donnell card was done by George Hatch, and the Richards card was done by H. Bencke, two of the better lithographers of the time. Many an evening was spent gluing the fancy cards into a scrapbook. There were over 100,000 different cards made, and many are highly collectible today.

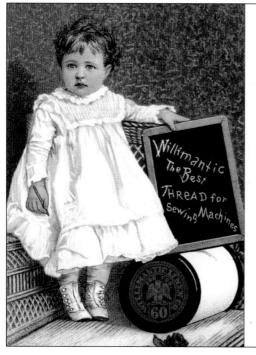

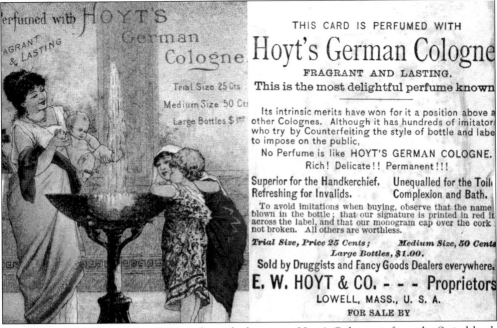

THIS CARD IS PERFUMED WITH

Hoyt's German Cologne

FRAGRANT AND LASTING.

This is the most delightful perfume known

Its intrinsic merits have won for it a position above all other Colognes. Although it has hundreds of imitators who try by Counterfeiting the style of bottle and label to impose on the public,

No Perfume is like HOYT'S GERMAN COLOGNE.

Rich! Delicate!! Permanent!!!

Superior for the Handkerchief. Unequalled for the Toilet
Refreshing for Invalids. Complexion and Bath.

To avoid imitations when buying, observe that the name blown in the bottle; that our signature is printed in red ink across the label, and that our monogram cap over the cork not broken. All others are worthless.

Trial Size, Price 25 Cents; *Medium Size, 50 Cents*
Large Bottles, $1.00.

Sold by Druggists and Fancy Goods Dealers everywhere.

E. W. HOYT & CO. - - - Proprietors

LOWELL, MASS., U. S. A.

FOR SALE BY

Trial Size 25 Cts

Medium Size 50 Cts

Large Bottles $1.00

DR. THOMAS E. DAVIS. This 1883 trade card advertising Hoyt's Cologne is from the Switchback Pharmacy. Davis opened the pharmacy on East Front Street in 1876. He was an 1867 graduate of the Jefferson Medical College in Philadelphia and was listed as "a dealer in drugs, patent medicines, chemicals, fancy and toilet articles, brushes, perfumery, etc."

Established 1876

DAVIS' SWITCH BACK PHARMACY

SUMMIT HILL, PA.

"The Drug Store of Quality"

PATIENT'S NAME ..

ADDRESS ...

℞

DAVIS'S SCRIPT PAD. Davis was widely known for making his own compounds. Some include Switchback Sarsaparilla, a blood purifier and pep drink, Switchback Cough and Cure, Switchback Blood and Liver Pills, and Switchback Cleanzine, a cleaner for cloth and leather. Davis also ran for Republican nomination of the state assembly in 1912.

PRESCRIPTIONS OUR SPECIALTY

.. M. D.

If you get it at
DAVIS' its right Date................... Reg. No................

GEO. BRON,

Expert Watch Repairer

Dr. Davis' Drug Store, Summit Hill, Pa.

DRAWING COUPON

No. 759

This Coupon Entitles You to a Free Drawing on All the Following Articles.

Genuine Diamond Ring, Solid Gold Watch,
Solid Gold Locket,
Solid Gold Chain, Pair of Solid Gold Cuff Links,
Solid Gold Signet Ring or Pair of Ear Rings.

Date of Drawing Will Be Announced in Lansford Newspapers and My Window Display.

 9

GEORGE BRON. George Bron was a watch repairer that ran his business out of the Switchback Pharmacy. As it is customary now to use sweepstakes to keep customers happy and returning for business, it was also common back in the early 1900s. This coupon entitled the winner to one of six articles of jewelry.

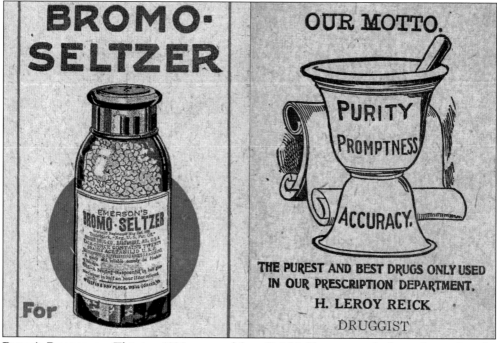

REICK'S PHARMACY. This is a 1922 note pad from Reick's Pharmacy, which was located in the Independent Order of Odd Fellows building on East Front Street between Chestnut and Oak Streets. Reick opened his business in the late 1890s.

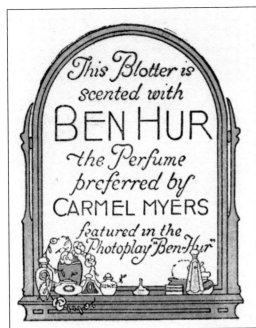

This Blotter is
scented with

BEN HUR

the Perfume
preferred by
CARMEL MYERS

featured in the
Photoplay "Ben-Hur"

See the

Ben Hur Photoplay

at the

LYRIC THEATRE
SUMMIT HILL, PA.

NOW!

LYRIC THEATER. The Lyric Theater opened in 1912 under the owners of Bookmaker and Floum. The silent movies of the time were set to piano selections based on the action on the screen. This perfume blotter was handed out for the photoplay *Ben-Hur*, which opened in 1925. Admission to the theater was 10¢, while children were admitted for half that price.

479

Grand Drawing

For a

$40 Howard Gold Watch,

For the Benefit of

Diligence Fire Company's Suit Fund

OF SUMMIT HILL

To be Chanced off on

Saturday, Sept, 4th, 1915

At Picnic to be held by the Company

TICKETS - - - 15c

DRAWING GOLD WATCH. This coupon for a $40 Howard gold watch was made possible by Dr. W. N. Davis. The drawing benefitted the Diligence Fire Company suit fund and was held the Saturday before Labor Day at the picnic. Interestingly, Davis was running for county treasurer on the Republican ticket in the upcoming primary election.

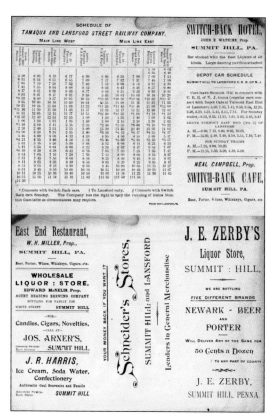

TROLLEY SCHEDULE. This is the Tamaqua and Lansford Street Railway Company time schedule from the early 1900s. The trolley's first run was in May 1897. Stops were made in Lansford, Coaldale, Gearytown (Manilla Grove), and Tamaqua. The businesses listed on the card were some of Summit Hill's finest bottlers, restaurants, and general stores.

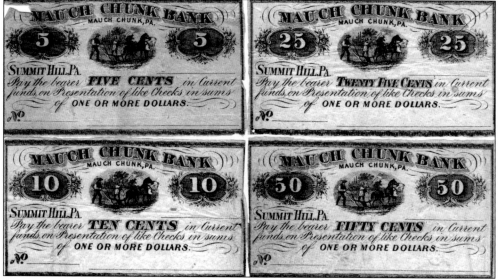

CIVIL WAR FRACTIONAL CURRENCY. During the Civil War, coins all but disappeared from circulation due to people hoarding them because the government was trying to conserve metals for the Civil War. Banks and even merchants issued their own money. Of course it was only redeemable at that bank or business. These fractional notes were issued to businesses in Summit Hill by the Mauch Chunk bank.

Four

EDUCATION

THE 1901 COMMENCEMENT
PROGRAM. This is a souvenir
handed out for the 1901
graduating class held at the
armory hall on May 24,
1901. Class valedictorian
was Thomas Lynn, and
salutatorian was Sarah
Thomas. Diplomas were
handed out by school board
president Thomas Walton.
The class had 11 graduates
that year.

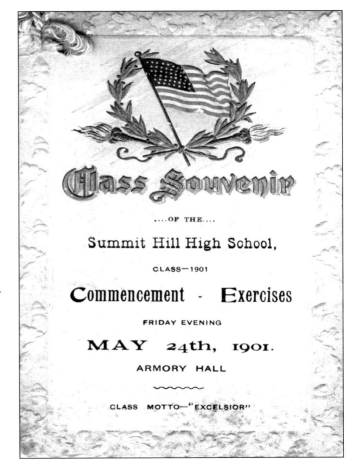

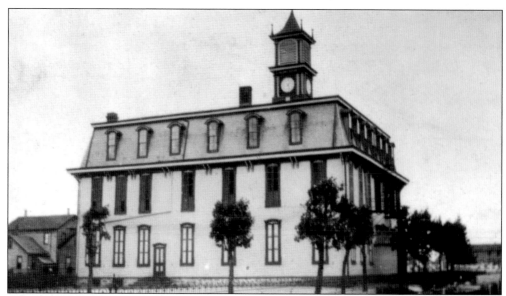

LINCOLN BUILDING. The earliest education in town began in the 1830s, when Lehigh Coal and Navigation Company built a log cabin at the west end of town furnished with rough benches and desks. The first teacher was George Adams, and he taught a four-month term. A decade later, there were many ungraded schools in town. In 1854, free public schooling became mandatory, after which classes were divided into six grades. In 1875, the Lincoln School building was erected for all students by town contractor John Breslin on Hazard Street. As enrollment and interest in education increased, a three-year high school was established, and the first class graduated in 1889 with two students, Margaret Bynon and Lizzie Clark. The building was also the home of the town clock, which was kept in running order by Diak Stoudt. The school bell, which called many a student to class, now has a home in Ludlow Park. The school was razed in 1962 for the new post office building.

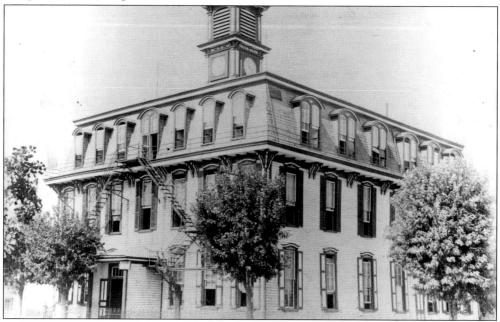

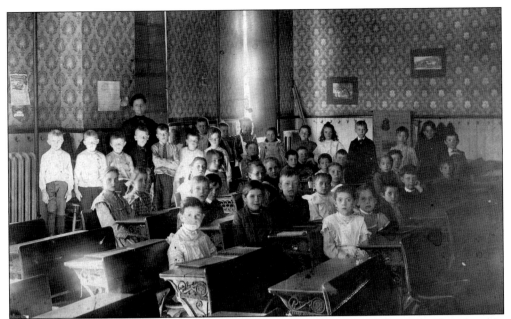

LINCOLN CLASSROOM. This picture is of Miss Kline's class from the 1880s, with 42 students in the room. The students' names and grades are unknown. Class sizes started to dwindle in the higher grades as the boys went off to work in the breakers.

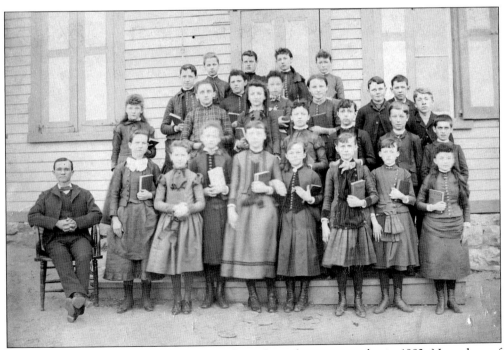

UPPER GRADES, 1882. These are the students from the upper grades in 1882. Note that, of the 27 students, only four are boys. At this time, there was still no official high school and no graduating classes. However, by 1900, 51 students called themselves Summit Hill alumni.

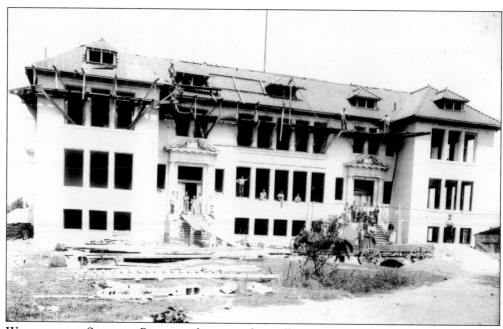

WASHINGTON SCHOOL. Because of increased enrollment and to better provide improved learning settings, a new school building was needed. In 1911, Andrew Breslin was the contractor hired to construct the new building for $65,000 next to the Lincoln School. For the 1914–1915 school year, the high school switched to a four-year course, so there was no graduating class that year. It was during that decade that Lehigh Coal and Navigation Company opened collieries four through six in the Andrewsville area. A school covering the first six grades was provided in that area. The students then went to Summit Hill to finish their education. Today the building still looks the same as it did then, only now it serves as an apartment building.

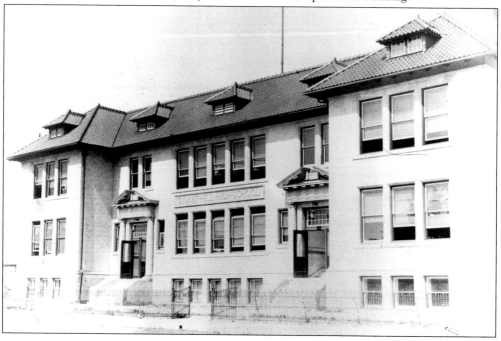

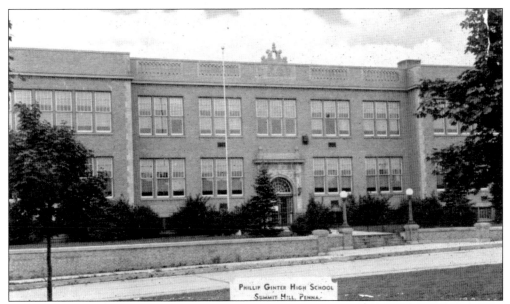

PHILIP GINDER SCHOOL. Further increase in attendance made it necessary for another school building. On ground donated by the Lehigh Coal and Navigation Company, a new building was constructed at the cost of $200,000 and was dedicated on November 26, 1927. The school district was then divided to have six grades in the Lincoln School building, three in the Philip Ginder building, and three in the high school. In the early-morning hours of April 14, 1971, the Philip Ginder School was gutted by fire.

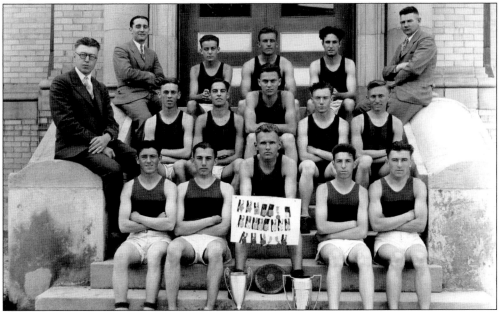

TRACK AND FIELD CHAMPIONS, 1928. This 1928 track and field team was the Carbon-Schuylkill League champions. Pictured from left to right are (first row) John McCullion, Steve Lacko, Giles Helps (captain), Herman Haldeman, and Walter Stanek; (second row) William Haldeman, Wallie Hammert, Harold Grey, Jimmie Newton, and John Wasely; (third row) Andrew Breslin, Joe Kastrava, and Ray Peterson. The coaches were not named on the picture.

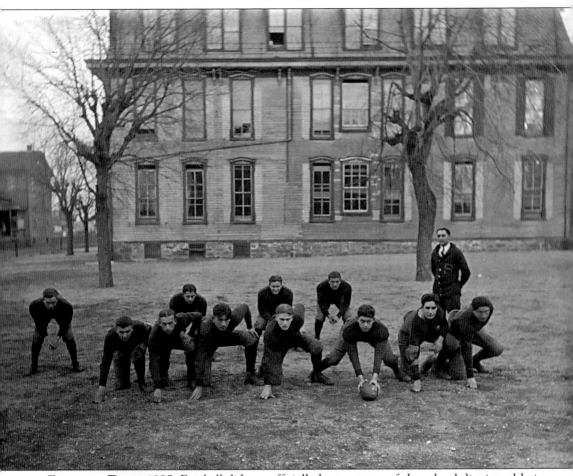

FOOTBALL TEAM, 1925. Football did not officially become part of the school district athletic program until 1924, although in 1921, the pastor of the Lutheran church, Rev. Walter Houser, coached a group of high school students that played a full schedule. Each student was on his own as far as equipment was concerned. Even though it was only the second year of having a program, the 1925 team, coached by Francis Gerber, became Panther Valley champions. Pictured from left to right are (first row) Walter Stanek, Stanley Kotchen, Mike Sebulesky, John McHugh, Frank Dougherty, Ray Peterson, and Cornelius Bonner; (second row) Mike McCullion, George Rasolin, Francis Gerber, and Joe Kastarava. Coach Gerber is standing.

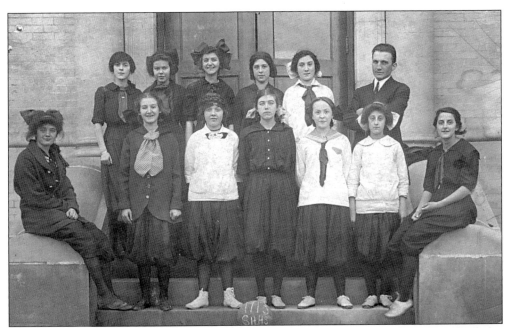

GIRLS' BASKETBALL TEAM, 1913. Basketball made its start in 1911 by then principal James Forrest, later the school doctor, making the 1913 girls' team one of the first squads of the school. No names were listed on the picture. At that time, any girls' athletic activities were frowned upon.

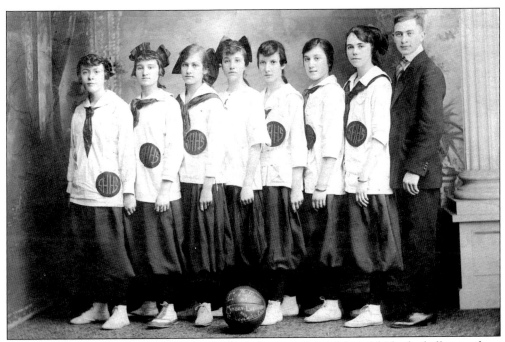

GIRLS' BASKETBALL TEAM, 1916–1917. This photograph is of the girls' basketball team from the 1916–1917 school year. The team was the Carbon-Luzerne and Schuylkill County League champions. The team members from left to right are Anna Crawford, Florence Boyle, Dorothy Creitz, Florence Kleckner, Lucy McMichael, Louise Derby, Mary Hoag, and coach M. Allison.

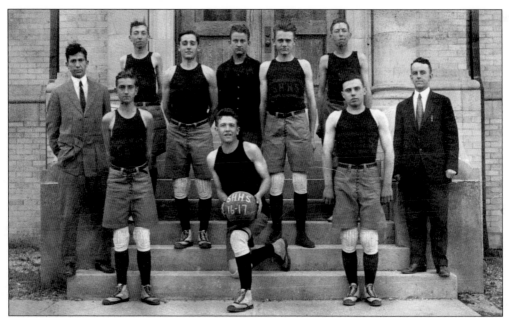

Boys' Basketball Team, 1916–1917. Basketball games were played in the hall of the Lincoln School building until 1914. That year, the court was moved to the basement of the new high school, but the ceiling was too low for games to be played. So the Eagle Hotel pavilion served as home court until 1919, when the hotel closed. From then until the Lincoln School was built, Park Hall was home court.

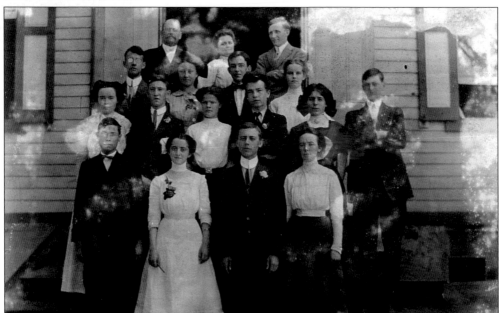

Graduating Class, 1910. This is the 1910 graduating class of Summit Hill High School. In no particular order, graduates are Belle Boyle, Harvey Remaley, Annie Breslin, Maurice Miller, Daniel McLaughlin, Cornelius Doughtery, Mary Cunnin, John McQuaid, Sadie Johnson, Mae Breslin, Francis Breslin, Luella Remaley, and Harold Neyer. In the back row are James Forrest, Jane Kline, and an unidentified man.

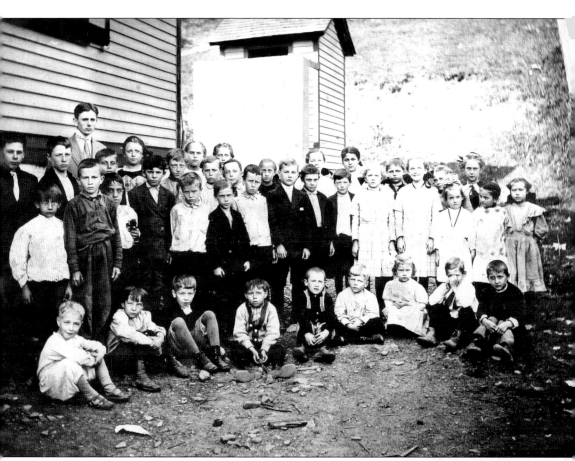

WHITE BEAR SCHOOL, 1910. These are the children of the one-room schoolhouse in White Bear, which was part of Mauch Chunk Township at the time. Pictured from left to right are (first row) Calvin Frantz, Harry Knepper, Harold Frantz, Russel Phillips, Tom Heffelfinger, Louis Creitz, Lenora Stamm, William Snyder, and John Vrablic; (second row) Earl Knepper, Orville Heffelfinger, Sterling Frantz, Bert Hettler, Charles Barnes, Harold Barnes, Stanley Barnes, Russell Miller, Clair Sorber, Bert Steigerwalt, Winifred Hough, Estella Hough, Lula Rex, Mary Barnes, and Ida Knepper. Students in the third row include Arden Sorber, Gordon Silvers, William Phillips, Ann Phillips, ? Steigerwalt, Ruel Jones, Nettie Beltz, Edne Creitz, Gertrude Embody, Margaret Evans, Mary Ferrence, ? Phillips, Elda Stamm, and Russell Miller. The teacher standing against the building on the left is Gordon Ulshafer. He later became principal of the Nesquehoning High School and earned his doctorate in education.

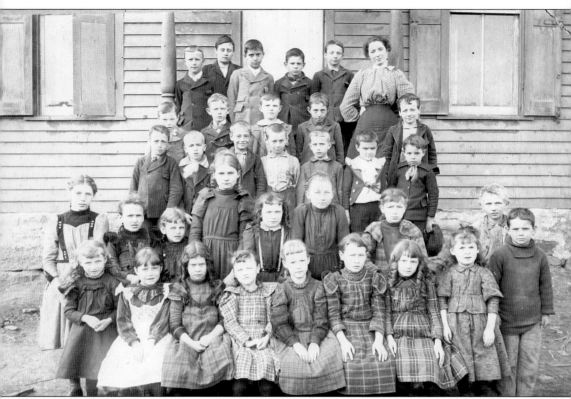

WHITE BEAR SCHOOL, 1915. The White Bear School was located west of the White Bear Hotel along Owl Creek Road. The wooden building was replaced in later years with a concrete building, which still stands today as a residence. Pictured from left to right are (first row) Mabel Wehr, Ida Miller, Carrie Moyer, Hattie Shellhammer, Carrie Oldt, Frances Moyer, Cora Hough, Bertha Hettler, and George Sorbers; (third row) Roy Miller, Walter Kutz, Rob Miller, George Miller, Ambrose Embody, Howard Wehr, and Warren Sorbers; (fourth row) Herman Hough, James Moyer, Charles Shellhammer, Ira Betz, and Ralph Cunfer; (fifth row) Wellus Embody, Calvin Miller, George Wehr, John Sorbers, and Carl Cunfer. The second row includes Kathryn Hough, Katie Creitz, Mary Creitz, Mary McSchaffrey, Bertha Kutz, and George Betz. Teacher Sally Jones contracted spinal meningitis during the school year and passed away.

Five

PLACES OF WORSHIP

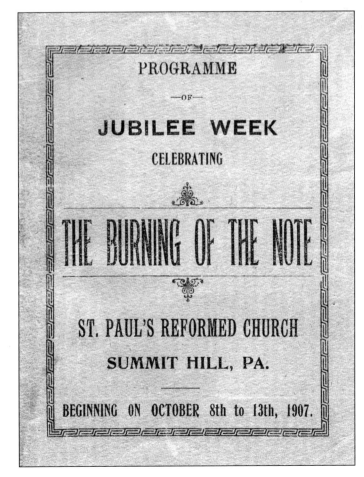

BURNING OF THE NOTE.
St. Paul's Reformed
Church celebrated the last
payment on the church
debt. The church was
debt free less than three
years after the cornerstone
was laid. Religion was a
large part of life in town.
There were six churches
in the late 1800s, covering
all denominations.

REV. RICHARD WEBSTER. Rev. Richard Webster was known as the apostle of the coalfields. He started over a dozen churches from Hazleton to Easton. Starting in November 1836, he walked from Mauch Chunk every fourth Sunday to hold services for the Presbyterians. In 1857, he wrote *History of the Presbyterian Church in America.*

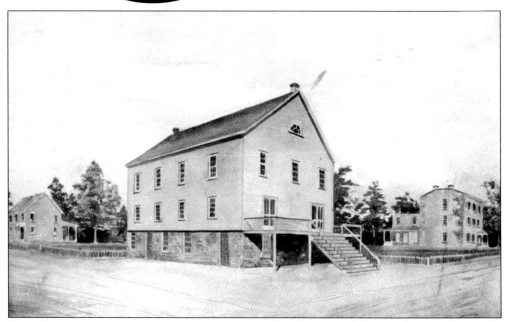

FIRST PRESBYTERIAN CHURCH BUILDING, 1846. This sketch, made by Charles Storch, is of the First Presbyterian Church building on White Street. "The new meeting house was a very plain building, resembling a factory of some kind at a cost of $1415." Two years later, the basement was renovated for the Sabbath school, costing $260. Until this time, the congregation met in a schoolhouse on Holland Street.

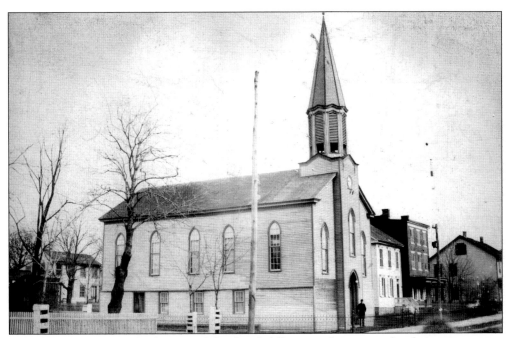

REMODELED, 1872. In 1872, because of the church falling into disrepair and with an ever-growing congregation and enrollment in the Sabbath school, the building was remodeled, given modern furnishings, and a bell tower was added at a cost of $3,500. The following year, a parsonage was built on the east side of the church.

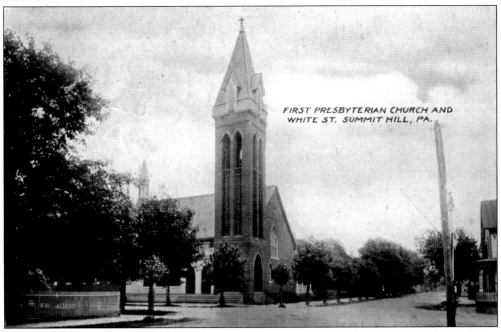

FIRST PRESBYTERIAN CHURCH AND WHITE ST. SUMMIT HILL, PA.

NEW BUILDING, 1895. The old Presbyterian building was razed in April 1895. It was on August 11 of that year Rev. James Robinson laid the cornerstone for the new building. In the seven months it took to complete the brick structure, the parishioners met in the Lutheran and Reformed churches, "a kindness granted which will never be forgotten by us."

St. Joseph's Catholic, 1880. St. Joseph's is known as the "Mother Church of the Panther Valley," since it was the first Catholic church in the area. It was in 1844 that ground was donated by the Lehigh Coal and Navigation Company to Fr. James Maloney for the purpose of building a church and creating a cemetery.

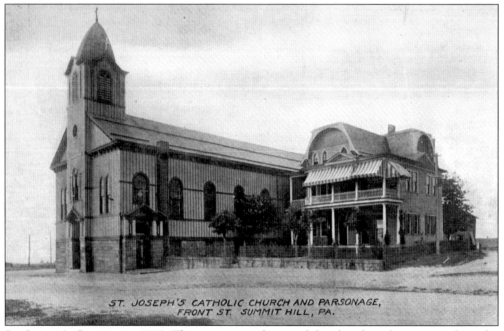

ST. JOSEPH'S CATHOLIC CHURCH AND PARSONAGE,
FRONT ST. SUMMIT HILL, PA.

St. Joseph's Catholic, 1905. This is a postcard view of the church and parsonage from the Millar Company. On June 21, 1882, the Very Reverend M. A. Walsh laid the cornerstone for the new building. Less than six months later, on December 10, the bishop of Harrisburg Rev. J. F. Shanahan conducted the dedication service.

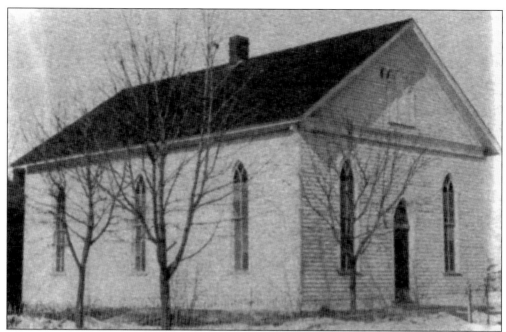

St. Paul's German Reformed and Lutheran Church. In 1865, on land purchased from the Lehigh Coal and Navigation Company for $200, the congregations from the Lutheran and Reformed churches united to erect a new building. On November 19, 1865, the cornerstone was laid for the building on the corner of Hazard and Chestnut Streets.

St. Paul's German Reformed and Lutheran Church's Interior, 1890s. This is a view of the inside of the combined church at Christmas sometime in the early 1890s. The men in the picture are secretary John Fink and superintendent Anthony Storch. Both churches shared this building until 1880, when the Lutheran congregation withdrew to have its own church.

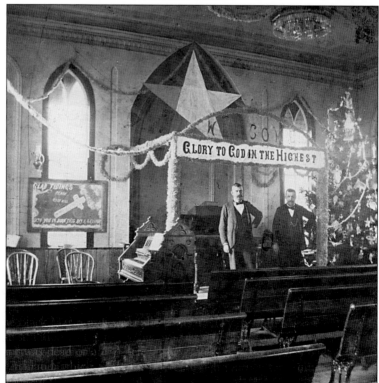

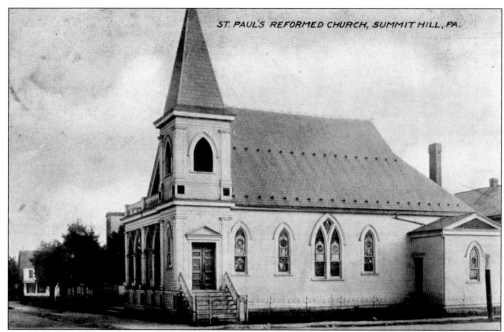

ST. PAUL'S REFORMED CHURCH, SUMMIT HILL, PA.

ST. PAUL'S REFORMED CHURCH. The splitting of the Lutheran and Reformed churches resulted in the Lutheran church receiving all the money and the Reformed church getting the property. In early 1896, the Panther Valley Electric Light, Heat and Power Company agreed to the "work and wiring" of the church building. It was in early 1903 that the congregation voted to build a new church building. On July 10, 1904, the cornerstone for the new building was laid. In the cornerstone were placed two coins from the original cornerstone, a holy Bible, Heidelberg catechism, constitution of the Reformed church, two German newspapers, two local newspapers, and a record of membership. The bell was installed on September 29, 1904, at a cost of $255. The new church was officially dedicated on February 12, 1905.

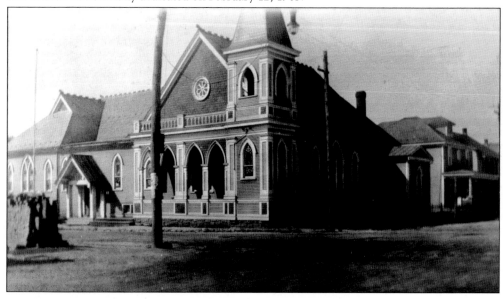

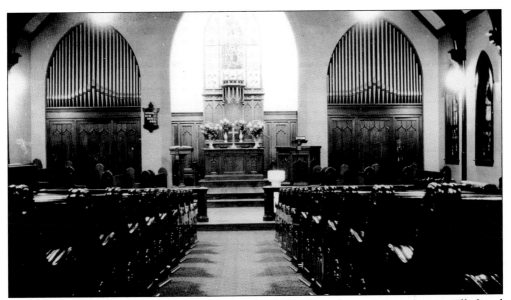

ST. PAUL'S INTERIOR. A couple months after the dedication, the pipe organ was installed and dedicated on February 12, 1905. It was under Rev. Edgar Kohler in the late 1920s that major renovations were made. A chancel was added, creating an altar that was centered, and rooms were added for the church school.

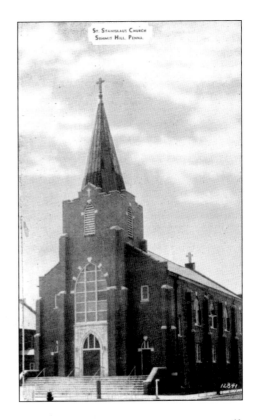

ST. STANISLAUS CHURCH. In trying to keep with their customs and heritage, the Polish community of Summit Hill requested that a Polish parish be established. With that provided, St. Stanislaus Church was formed in 1924. The congregation was allowed to meet at St. Joseph's until construction was done. In 1925, the church, school, convent, and rectory were dedicated.

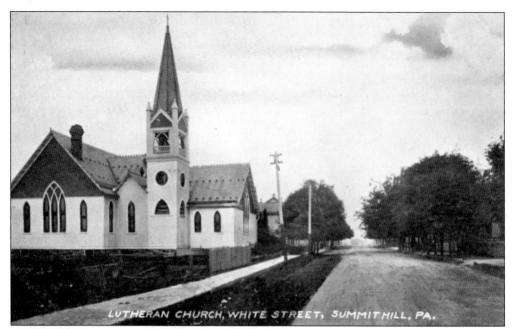

ST. PAUL'S LUTHERAN CHURCH. When the Lutherans left the combined church with the German Reformed, they purchased the old German Methodist church. The cornerstone for the present church building on West White Street was laid in 1895, and the church was formally dedicated on December 12, 1897. On March 24, 1901, the bell was consecrated, and in 1906, the missionary society purchased a wall model pipe organ.

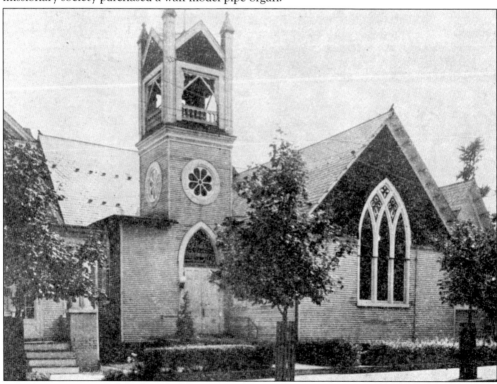

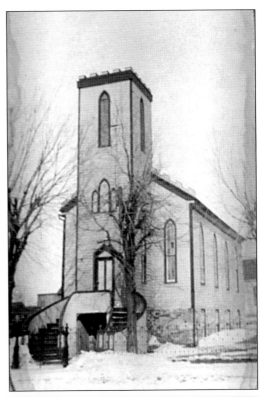

St. Philip's Episcopal Church. St. Philip's was incorporated as a church on November 22, 1849. The Reverend Peter Russell became the first pastor that year, and in 1850, the congregation built a church on West White Street. In 1882, many improvements were made to the building. The church was raised from its old foundation to make a basement for the Sunday school room and a new heater. In the nave of the church, new chandeliers, lamps, and pews were installed. What made St. Philip's special was that this was the only church in town to have a bell at the time to call the parishioners to mass, so it was known as the "bell church" for many years. The photographs show the church as it looked around 1900.

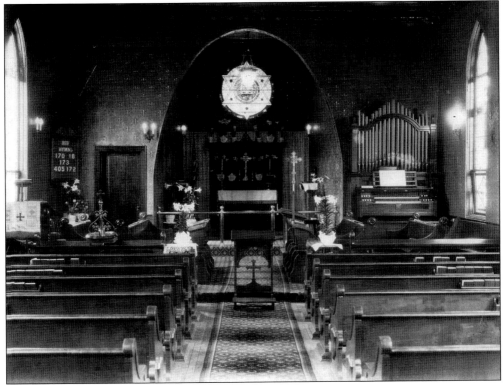

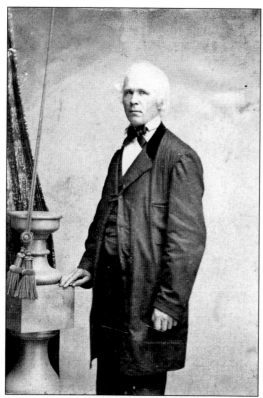

REV. HENRY DAVIS. This photograph of Rev. Henry H. Davis was taken by photographer Joseph Brown in the 1860s. It was in 1862 that the Philadelphia conference appointed Davis to serve Nesquehoning, Parryville, and Summit Hill. It was under his guidance that the worshippers were donated land on West White Street by the Lehigh Coal and Navigation Company in 1870, and a church building was erected.

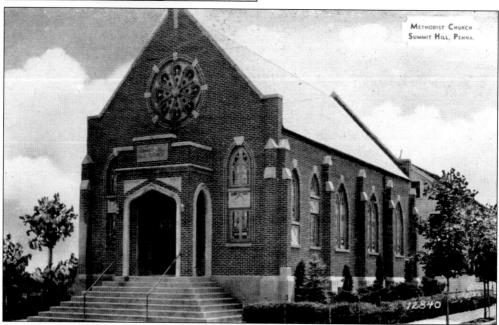

METHODIST CHURCH
SUMMIT HILL, PENNA.

METHODIST CHURCH. In 1872, a one-story church building was dedicated. Improvements were made over the next 25 years for growing attendance. In 1921, a parsonage and lot were purchased on East White and Oak Streets. The parsonage was moved to the rear of the lot, and the new Methodist church building was dedicated in November 1926.

Six

A RIDE ON THE SWITCHBACK RAILROAD

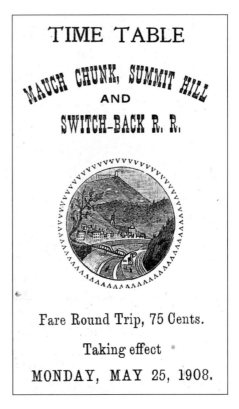

TIME SCHEDULE, 1908. In 1818, a wagon road from Summit Hill to Mauch Chunk was laid out for the purpose of hauling coal. It was the first time a road was planned using an engineer's level. Over time, a faster means for travel was needed. In 1827, the Switchback Gravity Railroad became the second rail line built in the United States, the first being in Quincy, Massachusetts, a year earlier.

TIME TABLE

MAUCH CHUNK, SUMMIT HILL AND SWITCH-BACK R. R.

Fare Round Trip, 75 Cents.

Taking effect

MONDAY, MAY 25, 1908.

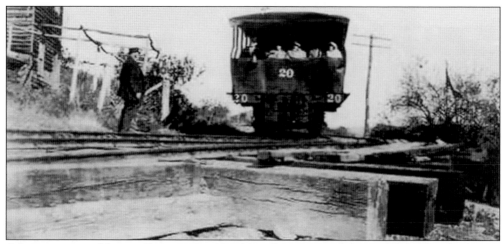

ARRIVING FROM MAUCH CHUNK. Car No. 20 makes its arrival from Mauch Chunk, about a nine-mile ride. It will make the turn and go over the barney pit and be pushed up the Mount Jefferson plane to Summit Hill. The back track was needed to get the empty cars back to the mines quicker. This section of the Switchback Gravity Railroad was engineered by E. H. Douglas and completed in 1845. (Courtesy of John Drury, Mauch Chunk Museum.)

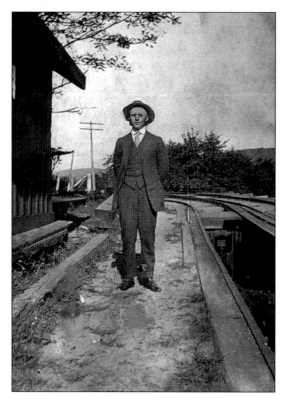

BARNEY PIT. Stan Henniger stands beside the Mount Jefferson barney pit. A barney car stayed in the pit until a car rode over. Then the barney car was pulled out of the pit and it pushed the car full of passengers up the plane. While one car was going up the plane, the other car was coming down.

BARNEY CAR. This photograph came from a stereo view from the Switchback Bazaar Curiosity Shop in Mauch Chunk. The empty barney car is rolling back into the barney pit to await its next car full of passengers. The outrigger legs, a safety feature seen between the wheels, automatically dropped down to stop any backward motion.

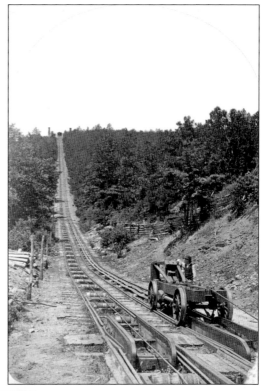

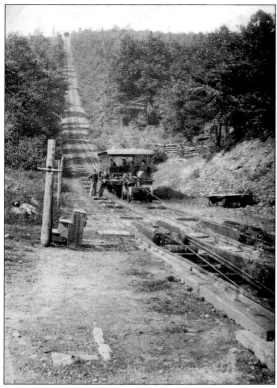

THE ASCENT. In this picture from the 1880s, a car begins its journey up the Mount Jefferson plane. The poles, visible on the left, carried a cable up to the engine house where a bell was attached. When a car at the bottom was ready to be pushed up, the conductor pulled the cable, alerting the person at the engine house to start the motors.

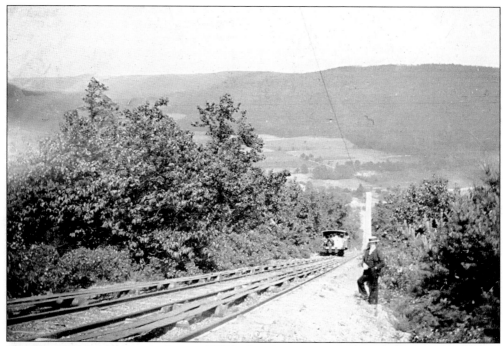

THE RIDE UP. In this view, taken in 1897 by Joe Arner, a car is about halfway up the Mount Jefferson plane. The ride between the barney pit and the engine house was almost 2,100 feet and took only about three minutes, about half the time as the ride up Mount Pisgah.

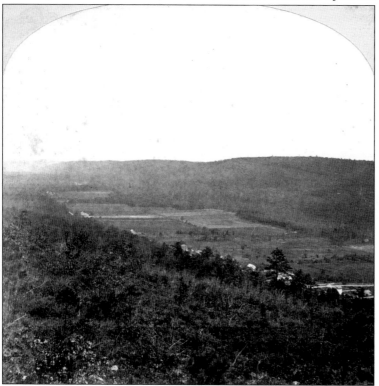

THE VALLEY BELOW. This view, from M. A. Kleckner, is looking from the top of the Mount Jefferson plane to the Bloomingdale Valley below. Kleckner provided some of the best and clearest stereo views of the Switchback Gravity Railroad and the coalfields of the Panther Creek valley in the 1870s.

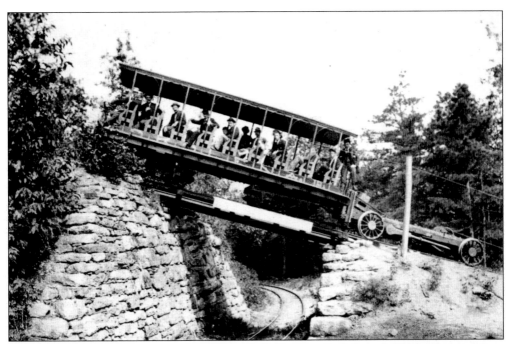

MOUNT JEFFERSON CROSSOVER. Approximately halfway up the Mount Jefferson plane is where the down track leading from Summit Hill to Mauch Chunk passed under the plane. Many times, cars were stopped here for pictures. This a great side view of the barney car behind the passenger car. Tourists take a moment to pose before they go on their way.

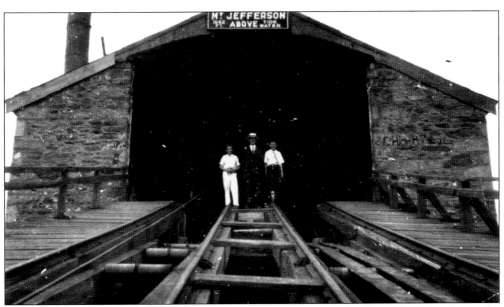

INTO THE ENGINE HOUSE. This is the view one would have as the car is about to go into the Mount Jefferson engine house. The two steel bands on the right were connected to the front of a barney car and were rolled up on large wooden wheels inside the engine house to pull a car up the plane.

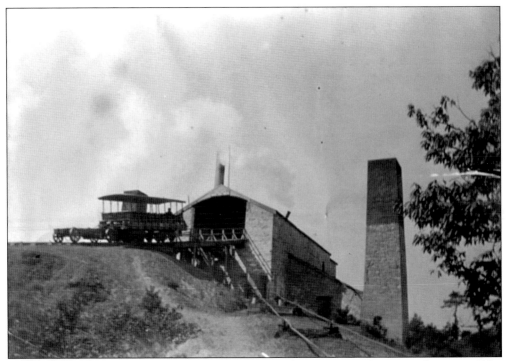

INTO THE CLOUDS. An empty Switchback railcar is about to enter the engine house atop the Mount Jefferson plane, possibly on a test run for the upcoming season. Thousands of tourists took this ride to enjoy the fresh mountain air and the great view of the valley below. The piping, at the bottom right, carried water from the spring cistern and filled a reservoir located nearby.

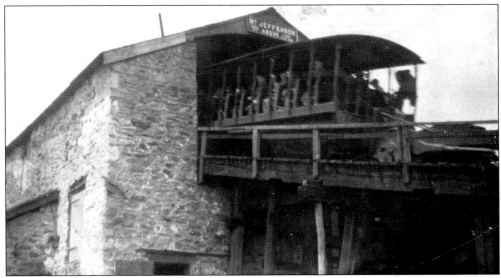

ENTERING THE ENGINE HOUSE. The car now enters the engine house were the barney car will come to a stop, and the momentum will carry the car through to the other side and send the passengers on their way into town. In 1872, the Switchback Gravity Railroad was last used to haul coal and was then only used for tourist rides.

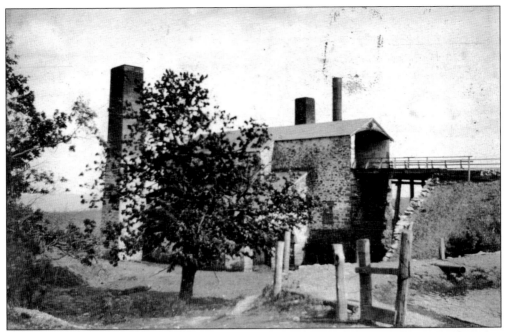

FROM THE RESERVOIR. This is the engine house as viewed from the northeast. The reservoir in the foreground held water to run the boilers in the engine house. Once a day, water was pumped up from the spring cistern, which was located below the return track. The stone pillars that carried the piping are still intact.

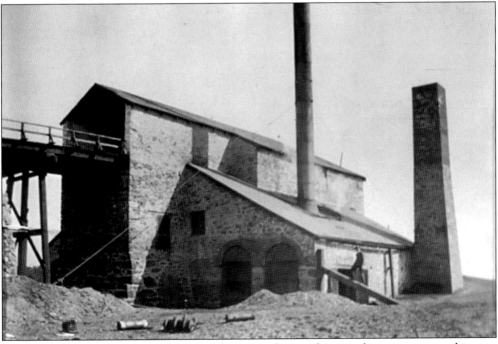

SOUTHWEST VIEW. Here is a full view of the engine house, showing the new cast-iron chimney. The old stone and brick chimneys were not used after the new boilers were replaced in the spring of 1900 in time for the opening of the season.

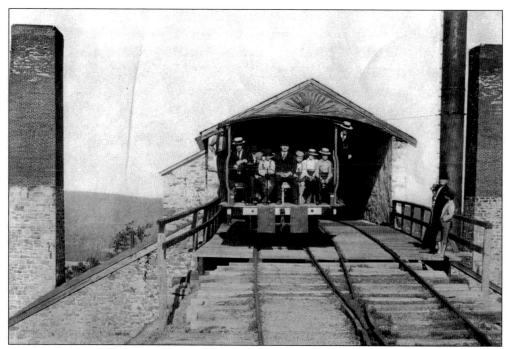

INTO TOWN. This view is of the car leaving the engine house, its journey up the Mount Jefferson plane complete. It was a slow roll into Summit Hill, as the drop from here to the depot on Front Street was only 45 feet in the nearly one-mile ride.

PHOTOGRAPH OPPORTUNITIES. Many tourists, as well as locals, had their picture taken along the 18-mile stretch of the Switchback Gravity Railroad. The entire route had picturesque scenes. In this photograph, Hazel Gormley poses in front of the Mount Jefferson engine house in the 1920s.

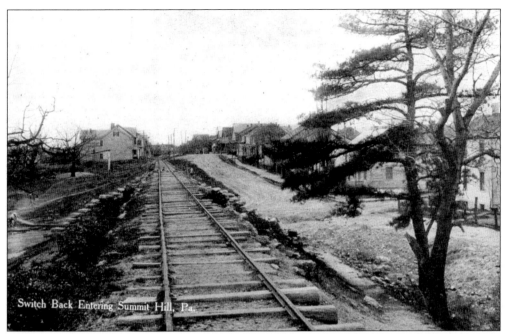

TOWN IN VIEW. This postcard image was taken in the early 1900s. Much of the track from the engine house into town had to be elevated since the drop was so small—only 45 feet from the engine house to the station. This view is where the car passed on the Pine Street crossover bridge.

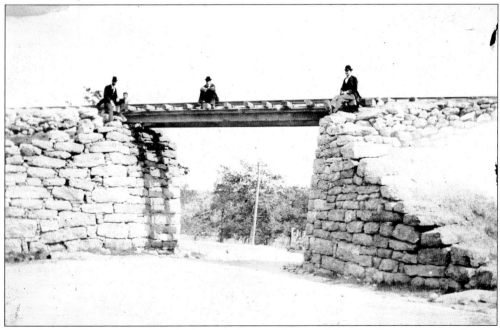

PINE STREET CROSSOVER. This is the only known picture of the Pine Street crossover bridge, taken in 1897. The short trestle was located about halfway between the Mount Jefferson engine house and the Switchback Gravity Railroad station. Remnants of the east side of the wall still exist, with a small park having a coal car on display dedicated to the crossover area.

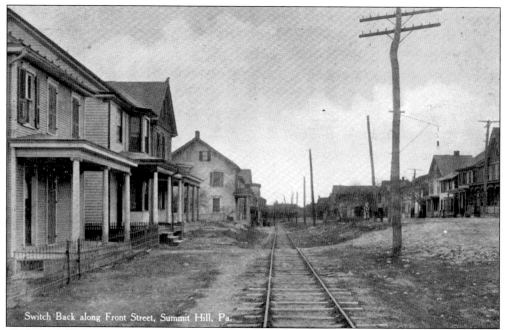

Switch Back along Front Street, Summit Hill, Pa.

OAK STREET. As the car heads toward the depot, the first houses the passengers see are near Oak Street. As seen here, the tracks were precariously close to the houses. The safety record of the railroad was always perfect; there was never an accident reported. Many accidents occurred but were quickly forgotten to keep the romance of the railroad alive.

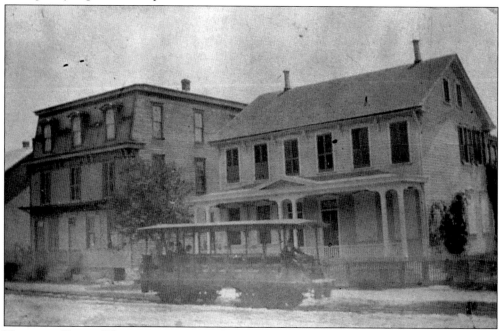

NEAR THE DEPOT. The car now passes in front of the residences of W. Swank and A. Schneider and is about to head into the station. This is an early car that was used with nine open seats. Later the cars were lengthened to have 13 seats. The brakeman usually sat with the passengers and rang the bell when departing the depots and at crossings.

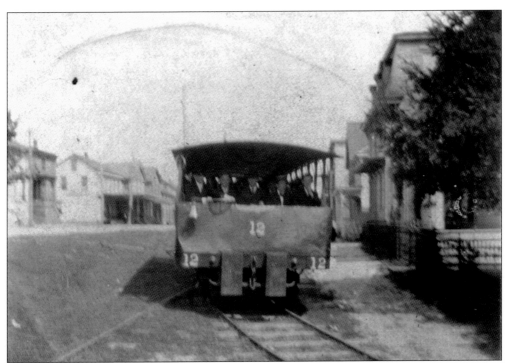

CAR NO. 12. This image from the late 1890s shows car No. 12 slowing down and entering the turn to the station. After departing the car, a tourist had many options from shopping in the local businesses, being guided around the burning mines, or taking a trolley into nearby Lansford or Tamaqua.

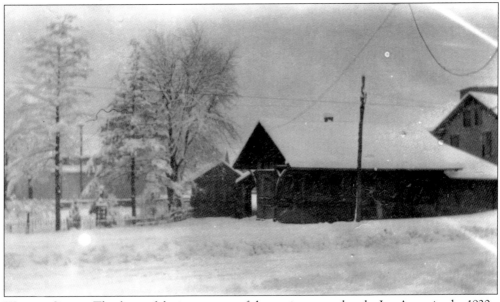

WINTER SCENE. This beautiful winter scene of the station was taken by Joe Arner in the 1920s. The usual operating season for the Switchback Gravity Railroad was between May and October. All was calm and quiet when this picture was taken, but when an excursion came through, tourists came into town by the thousands.

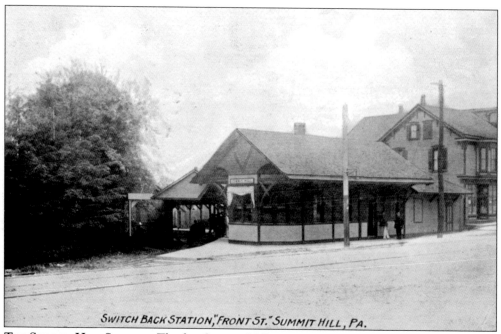

SWITCH BACK STATION,"FRONT ST." SUMMIT HILL, PA.

THE SUMMIT HILL STATION. The first Summit Hill station was probably built in the early 1870s, about the time the Switchback Gravity Railroad stopped being used to haul coal to Mauch Chunk. The railroad was then strictly being used for passengers and tourism. In June 1890, the small station was replaced with a bigger building to accommodate the large amount of tourists passing through town. Besides tickets being sold there, passengers were also able to buy souvenirs, such as fossils, sea shells, anthracite carvings, and photographs. Next to the station on the left was a building where the cars were stored. A sign to the right advertises the Depot Restaurant, which was owned J. R. Harris. It was in June 1938, less than a year after the famous railroad was sold for scrap, that the station was dismantled and lost for good.

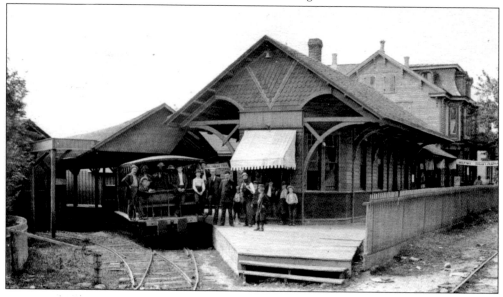

COMING OFF THE TURN. This picture shows a car coming off the turn from the depot about to head down Holland Street. The children of town often offered their services as tour guides. Also youngsters often chased after the cars, hoping a tourist would throw a coin their way.

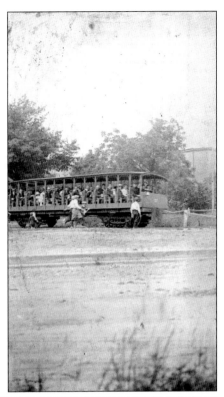

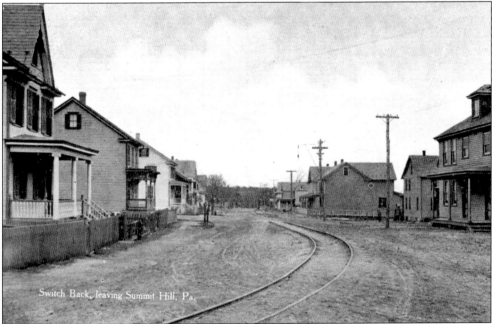

HEADING DOWN HOLLAND STREET. After coming off the turn, the car headed down Holland Street on its way back to Mauch Chunk. According to a map from 1854 of Summit Hill, the first turn was located between Chestnut and Oak Streets, around the area of Abbott and Lockhart's Foundry, which burned down in 1871.

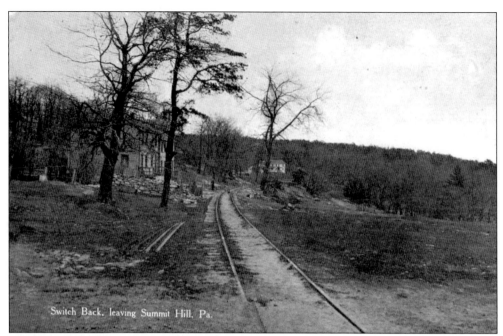

Switch Back, leaving Summit Hill, Pa.

INTO THE WOODS. These early postcard views show the vicinity of what are now Oak and Pine Streets. With the completion of the No. 7 tunnel through to Hauto, coal was no longer hauled on the Switchback Gravity Railroad. For a time in 1872, the Central Railroad of New Jersey thought about scrapping the famous railroad. But level heads prevailed, and many improvements were made for tourism. A pavilion was built on the top of Mount Pisgah, and more excursions were planned, including ones that did not require an overnight stay. Overall, 1872 proved to be a very good year for the Switchback.

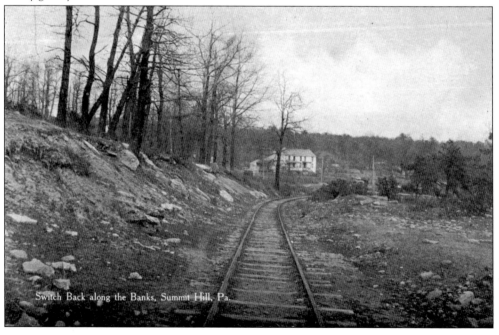

Switch Back along the Banks, Summit Hill, Pa.

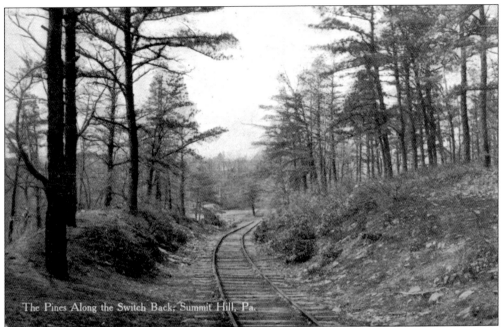

The Pines Along the Switch Back, Summit Hill, Pa.

STONEY LONESOME. This stretch of track that runs into Mauch Chunk is the down track that was originally built in 1819 as a wagon road. According to one brochure from the 1920s, "Riding around the mountain with locomotive speed, the numerous landscapes stretching about on every side, changing as rapidly and charmingly as the views in a kaleidoscope keep the tourist rapt in a continual state of enthusiastic admiration; the cool bracing atmosphere, the novelty of whirling along the road at so great an elevation without any apparent motive power."

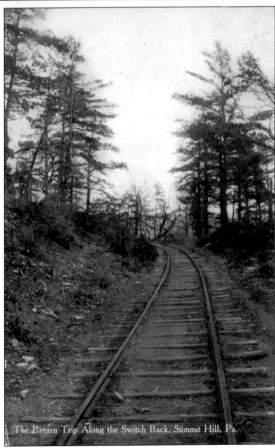

The Return Trip Along the Switch Back, Summit Hill, Pa.

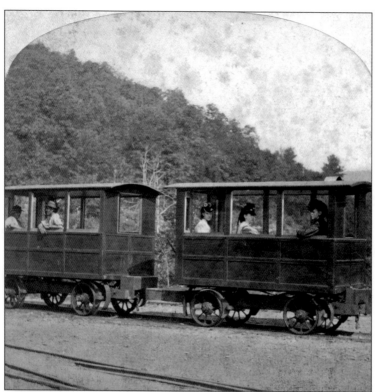

THE FIRST CARS. Tourists wait to ride up Mount Pisgah in this stereo view taken by M. A. Kleckner in the late 1860s. These were the original passenger cars made from the coal cars. Early Switchback Gravity Railroad visitors were treated to the full tour by getting rides through the Panther Creek valley to view the mines and breakers. Josiah White permitted this as long as they did not interfere with the coal transportation.

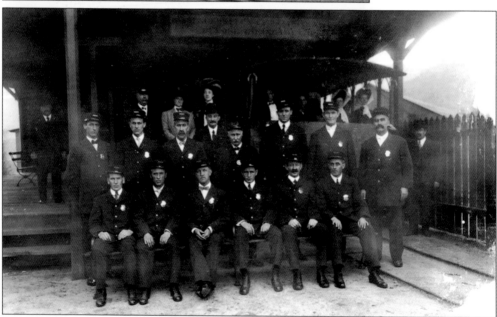

SWITCHBACK POLICE. The Switchback police take a break to pose with tourists at the station in Mauch Chunk. Scott Brower is pictured in back by the women. Also pictured from left to right are (first row) J. Barry, Tenny Clark, J. Sabach, Paul Acker, L. Rickenback, and E. J. McGinley; (second row) J. Trout, Blocker Mench, Manus Heiney, Bill Conley, Joe Coll, F. Kanake, Derby Hat, and C. Blakeslee. J. M. Dolon is by the fence.

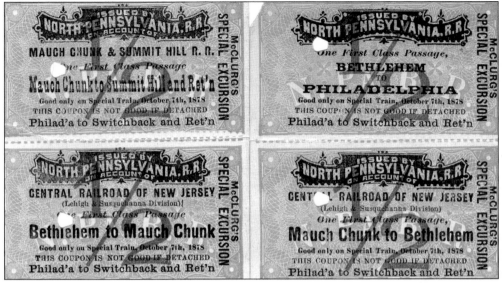

EXCURSION TICKETS. Excursions in the latter half of the 1800s brought in thousands of tourists on any given weekend, especially if it was a holiday. This set of round-trip tickets was issued for October 8, 1878, by McClurg's from Philadelphia for the North Pennsylvania Railroad to the Switchback Gravity Railroad and back.

CENTRAL RAILROAD OF NEW JERSEY.

...er Time Table of SWITCH-BACK, Commencing May 22, 1876.

Leave MAUCH CHUNK	Arrive SUMMIT HILL	Leave SUMMIT HILL	Arrive MAUCH CHUNK
8.30 A.M.	9.15 A.M.	6.40 A.M.	7.10 A.M.
9.15 "	10.00 "	9.30 "	10.00 "
11.20 "	12.05 P.M.	10.05 "	10.35 "
12.00 M.	12.45 M.	12.30 P.M.	1.00 P.M.
2.30 P.M.	3.15 P.M.	1.15 "	1.45 "
4.00 "	4.45 "	3.40 "	4.10 "
5.10 "	5.55 "	4.55 "	5.25 "
6.15 "	7.00 "	6.10 "	6.40 "

...aches leave the Railroad Stations and Hotels **Thirty Minutes** before the trains Upper Mauch Chunk, and meet all trains from Summit Hill.

TABLE OF DISTANCES

ON THE LINE OF THE

SWITCH-BACK RAILROAD

AT

MAUCH CHUNK.

Length of Mt. Pisgah..	2,322 feet
Height of Mt. Pisgah......................	664 feet
Distance from Mt. Pisgah to Mt. Jefferson..6⅜ miles	
Fall from Mt. Pisgah to Mt. Jefferson.... ..	302 feet
Length of Mt. Jefferson.................	..2,070 feet
Height of Mt. Jefferson.....................	462 feet
Distance from Mt. Jefferson to Summit Hill....	1 mile
Fall from Mt. Jefferson to Summit Hill........	45 feet
Grade from Summit Hill to Mauch Chunk to the mile..........................	96 feet
Summit Hill above the Lehigh............	975 feet
Mt. Pisgah above the Lehigh	850 feet
Mt. Pisgah above the tide................	1,500 feet

TIME SCHEDULE, 1876. This 1876 time schedule, with complete listing of distances on the back, has the Switchback Gravity Railroad running eight cars per day during the summer. This year proved to be a slow one for the railroad because of all the hype over the Molly Maguires trials. In fact, the opening of the season was pushed back well into the end of June.

MAUCH CHUNK SWITCH-BACK RAILWAY	MAUCH CHUNK SWITCH-BACK RAILWAY
SOLD_____19....	MAUCH CHUNK —TO— SUMMIT HILL AND RETURN
MAUCH CHUNK —TO— SUMMIT HILL AND RETURN E 24478	On account of the reduced rate at which this ticket is sold it is good only on the date stamped. E 24478
	Pres. & Gen. Mgr.

SWITCHBACK PASS. The Switchback Gravity Railroad was leased to brothers Alonzo P. Blakslee and Asa P. Blakslee from the Central Railroad of New Jersey in 1899. In 1912, a year after Alonzo passed away, Asa became the lessee of the railroad and incorporated it. The corporation was then known as the Mauch Chunk Switchback Railway Company.

Mauch Chunk Switch-Back Ry.

1531 Summit Hill —TO— MAUCH CHUNK

ONE TRIP, SEASON 1925

Mauch Chunk Switch-Back Ry.

2859 Summit Hill —TO— MAUCH CHUNK

ONE TRIP, SEASON 1925

TICKETS, 1925. The 1925 season was the first year that a profit was barely made and proved to be the beginning of the end. Much of the problem was the Mauch Chunk Switchback Railway Company was not equipped to handle the automobile, whether it was the parking around the depots or the roads leading into Mauch Chunk. A sharp drop-off of excursions, aging equipment, and vandalism only exasperated the issue.

Seven

THE BURNING MINES

GREETINGS FROM SUMMIT HILL. This handmade card was sent in 1907 and made by the Philadelphia Post Card Company. Tourists coming to Summit Hill were excited about seeing the burning mines. The fire moved in a westerly direction, and during the first 50 years went through nearly one mile of coal, burning millions of tons of fine anthracite.

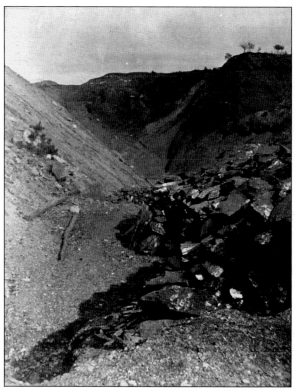

THE BURNING MINES. As the story goes, "Dan Boyle was the bottom man of slope number one and among other duties he had the job of tending the fire in the stove placed at the bottom of the slope for the miner's comfort. One morning when he came in late, he did his best to get the fire going for the chilled workers who would soon come to mine. He shook down the fire and some of the hot coals fell into the ash pit and these were shoveled into a nearby mine car. A young mule driver by the name of Moore was instructed to move the car into an old unused gangway. For unknown reasons the car remained and the coals had a weeks start before being discovered." The pictures are from G. F. Gates's stereo views. (Left, courtesy of Joe Slakoper.)

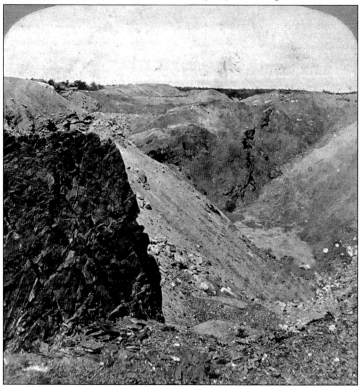

ZELNER STEREO VIEW. One of Summit Hill's most unusual and main attractions outside of the railroad was the burning mines. The fire was discovered in the middle of February 1859 in the mine that was opened in 1850 on the west side of town. This early-1870s Zelner stereo view was taken near the No. 1 slope, where the underground fire got its start.

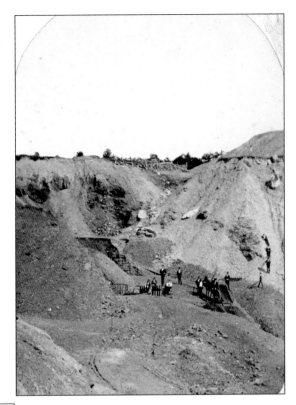

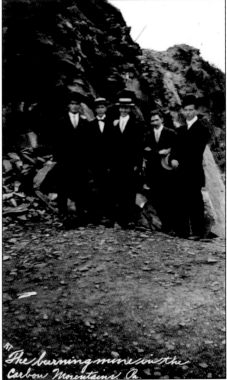

The burning mine in the Carbon Mountains, Pa.

THE TOURIST. Passengers who rode the Switchback into Summit Hill were often escorted by the town's children as tourist guides. Much of the scenery was desolate, but still many tourists posed on the warm grounds for pictures, such as this one, for memories in their scrapbooks and photograph albums.

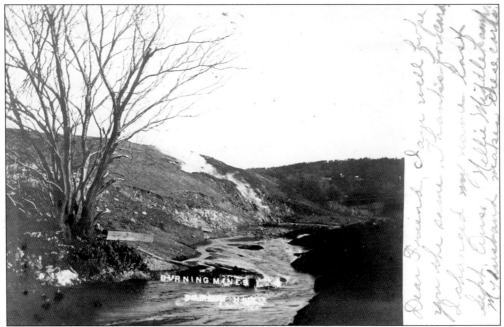

Burning Mines Water. This view shows water washing away from the area of the burning mines, possibly from the company's sluicing project to flood the fire. There was not much of a scene unless the smoke or flames broke through the surface. This postcard was from Nellie Middlecamp, who signs off, "My husband makes these cards."

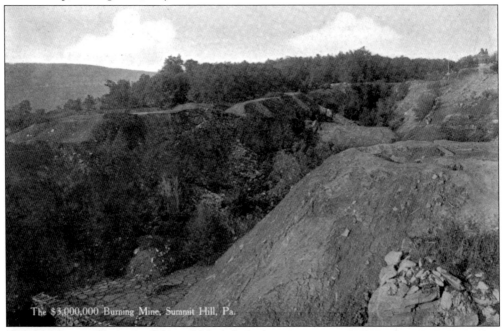

The $3 Million Burning Mine. Although the burning mines were a major tourist attraction for those traveling on the railroad and for the town, the company was losing money on a daily basis; first for trying to douse the fire and second because of all of the coal that was being consumed by the underground inferno.

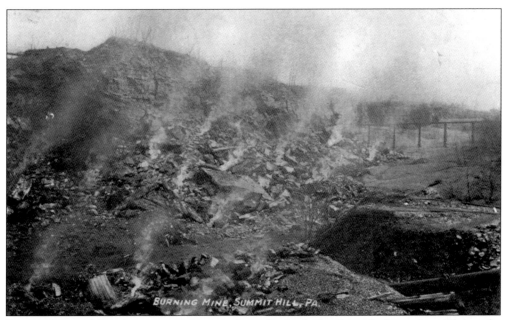

RISING SMOKE. Many tourists came to see where the fire broke through the surface. The smoke added to the visual effect and the surrounding scenery. The only drawback was the awful sulfur stench that sometimes became a nuisance to the nose. At night, glowing embers could be seen through the cracks in the surface.

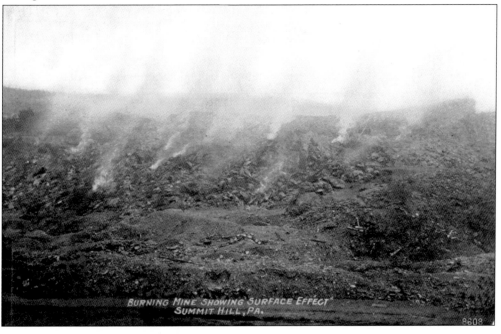

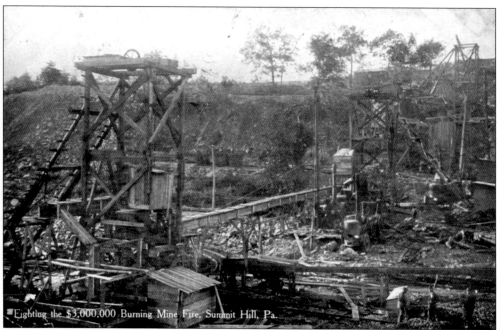

Fighting the $3,000,000 Burning Mine Fire, Summit Hill, Pa.

MACHINERY. These postcards show some of the machinery that was used in fighting the underground fire. The apparatus seen here was used in what was called sluicing. It was a way of using channels to carry water to the burning mines. Flooding the mines did not do anything, as the heat was too intense to extinguish the fire. A second attempt was made by drilling holes into the coal seam and filling them with a mixture of coal and water. This seemed to work for a while, but the fire raged on. Time was of the essence since much of the coal that was being burned was money going up in smoke.

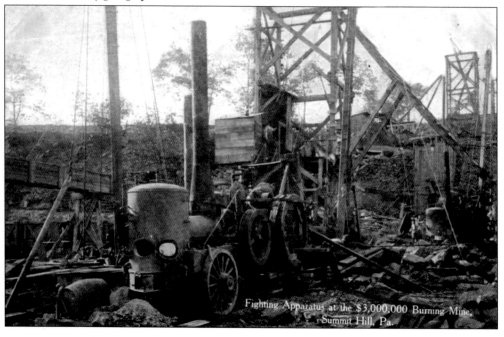

Fighting Apparatus at the $3,000,000 Burning Mine, Summit Hill, Pa.

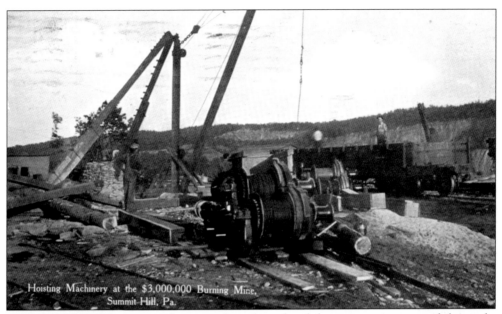

Hoisting Machinery at the $3,000,000 Burning Mine, Summit Hill, Pa.

RAILROAD VIEW. These particular views show the railroads hoisting equipment and the tracks into the burning mines. On the right of the postcard below is an elevated channel that was used to carry the water into the fire. What makes this postcard most interesting is the writing on the back and the date of September 8, 1911. It reads, "Dear friends, We are enjoying our trip to the hard coal mountains. Yesterday two men were murdered right near here. It is in today's N. American. One lives here. All excitement." The murders that this tourist was writing about were of Joseph Zehner and Samuel Watkins on the old road from Summit Hill to Nesquehoning. It appears to have possibly been a botched robbery, since Zehner was carrying the payroll for his workers. He had $4,200 hidden on the buggy, which was found. Police could only assume the gunshots frightened the horses and the thieves, for in fear of being caught, they did not go after the buggy. Two men were arrested in Parryville later that day, but they were acquitted in court.

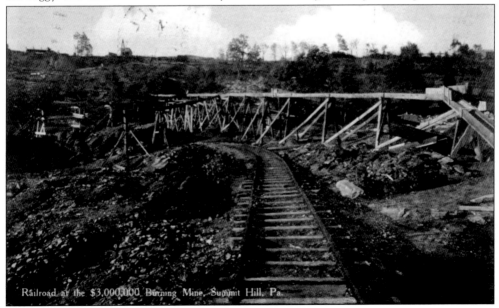

Railroad at the $3,000,000 Burning Mine, Summit Hill, Pa.

97

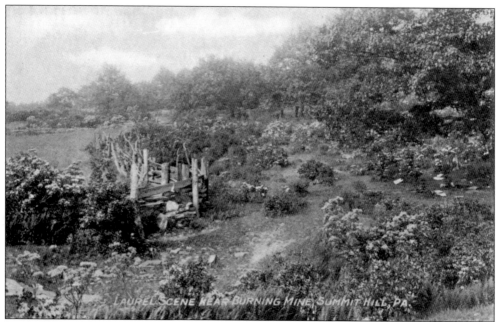

LAUREL SCENE. This scene shows what was called a "carpet field" around the burning mines. The ground was kept warm year-round, and much of the grass and ground cover stayed green. In the late 1920s, the area was strip mined, and nearly 21 million cubic yards of earth was removed over the next two decades. This proved to be the solution to end the underground fire after nearly a century of burning.

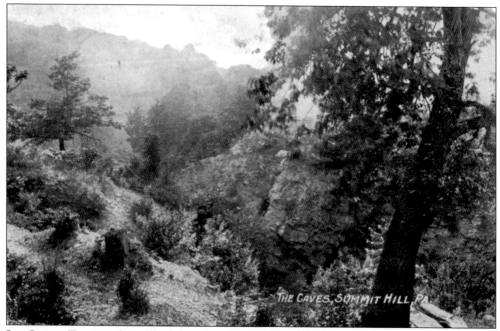

ICE CAVES. Tourists who walked over the warm ground of the burning mines were treated to the cool air of the ice caves. The caves were natural formations in Sharp Mountain opened by the collapse of the spring tunnel. The roof of the caves were covered with icicles.

Eight

MINING

THE BLACK MARIA. The Black Maria, as it was called, was used by the mines as an ambulance or hearse—whatever the situation called for. Whenever it came into town, many stared and wondered if the occupant was dead or alive. Before the Coaldale Hospital was built in 1910, the nearest one was in Ashland, which made for a long, rough journey for a miner who was badly injured.

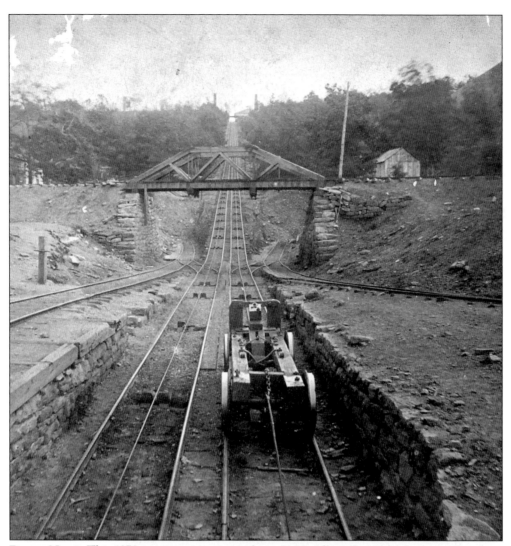

PLANE NO. 1. This 1870s stereoscopic view is from A. M. Allen's Switchback series. The plane was constructed in 1846 as a single track and carried all of the coal mined in the Panther Creek valley to Summit Hill. In town, the tracks ran just west of the armory and connected to the back track on Holland Street. The plane was over 2,400 feet in length and ran under the railroad track, which came from the old mine in Summit Hill. The single plane became a nuisance if there was a breakdown, as any hauling had to wait until repairs were made. A second set of tracks was added in 1854. There were a couple differences with this plane compared to Mount Jefferson. First, there was no barney pit. Coal cars were switched off to the side track and then rolled back in front of the barney car. Second, a single steel cable was used instead a pair of iron bands.

PLANE NO. 2.
This view from
M. A. Kleckner's
"A Trip Around
the Switchback
R.R." series is of the
Panther Creek plane
No. 2. It was also
called the Coaldale
plane, and the base
was near the No. 8
breaker. The loaded
cars were pulled to
the top, and then
gravity rolled them
to the base of plane
No. 1.

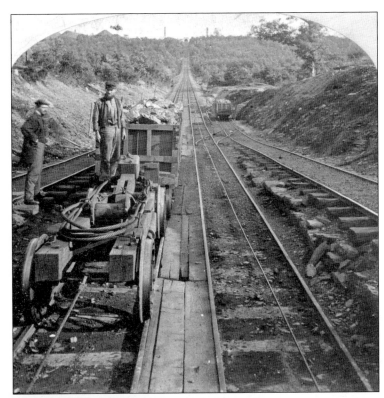

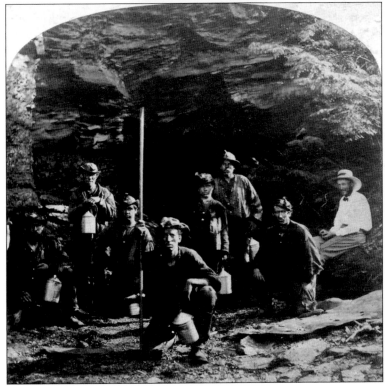

MINERS. Miners
pause for a
moment to pose
for Kleckner for his
Switchback series of
views. The card did
not identify which
tunnel these men
were working. The
man holding the
long rod used it to
pack the explosive
in the hole after it
was drilled out.

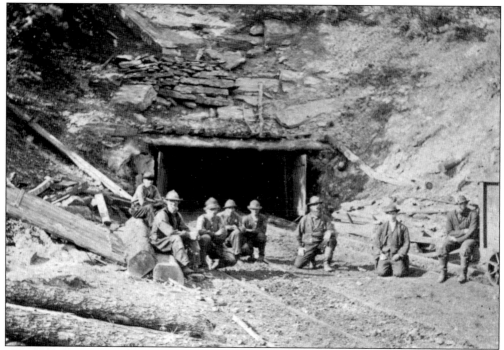

MINE TUNNEL NO. 8. Two more of M. A. Kleckner's views show miners and mules taking a moment before heading back to work. The No. 8 mine tunnel was located in Coaldale, just west of town. Cornelius Conner drove No. 8 in 1845. The mine had eight different levels, the deepest being 1,200 feet. It used over 1,400 mine cars and had 24 miles of track and tunnels. For any tourist coming through the valley, this mine offered tours when possible. The visitors' center offered proper clothing for the two-hour trip. One point of interest was a petrified tree millions of years old in one of the lower levels of the mine. The mine was closed in 1954 and the entrance sealed.

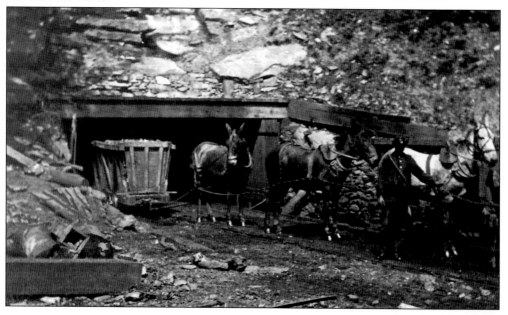

BREAKER NO. 8.
This was the first No. 8 breaker built in 1857 and was put out of service in 1873. The coal cars to the left are filled and about to head up plane No. 2 for delivery to Mauch Chunk. Kleckner was one of the first photographers to capture the early years of the Panther Creek valley.

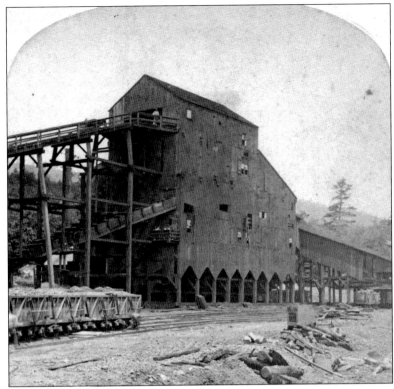

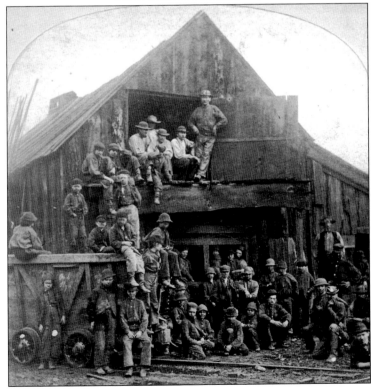

SLATE PICKERS SHANTY. This is the slate pickers shanty that was located by the No. 8 breaker. The company used young boys and older men for this job since they could not do the heavy work of underground mining. Kleckner had this group pose for him in the early 1870s.

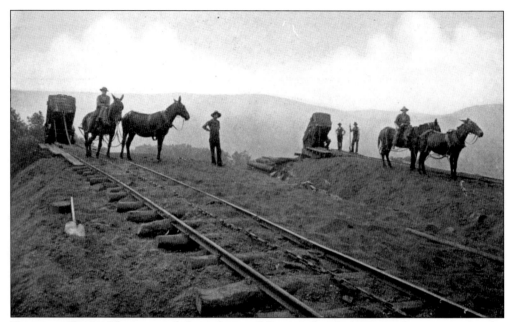

DUMPING CULM. This postcard shows how rail lines and mules were used to carry away the culm or useless by-product of mining. The cars came from the mines, were tipped over to dump the culm down the bank, and then the mules pulled the cars back to get filled again.

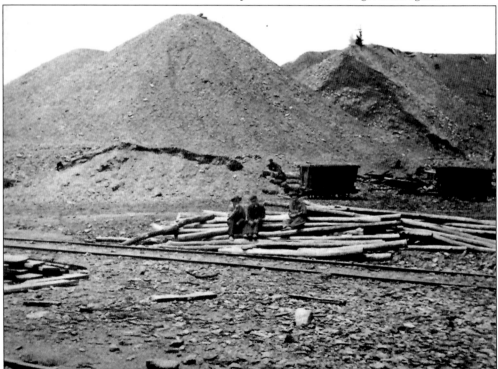

CULM BANK. This view from M. A. Kleckner shows the culm bank that was formed near the top of the No. 2 plane. From time to time, a culm bank caught on fire and left a sulfur smell in the air. Culm fires were somewhat easily extinguished if they did not go out themselves.

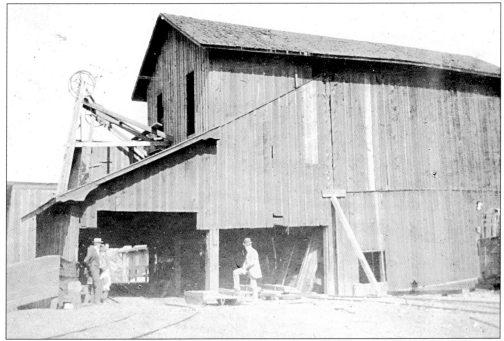

McCready's Breaker. This is a picture of Nate McCready's breaker in 1909. It was located on the southeast side of town. He died in a fall, and the breaker was dismantled in 1912. Breakers were used to separate the different sizes of coal and also to pick out any slate. In the early days, slate was picked out by young boys called breaker boys.

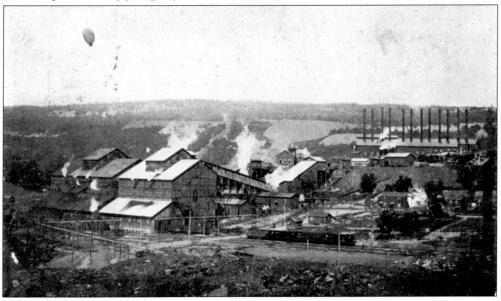

Coal Breaker No. 6. This is a postcard view of the No. 6 breaker in the Andrewsville section. The most unusual story to come from this breaker was from 1933. Charlie Llewellyn and Jimmy Whitehead were picking slate off the chute when Whitehead noticed the body of a baby coming down among the coal. Nothing ever came of identifying the infant, and it remains an unsolved mystery.

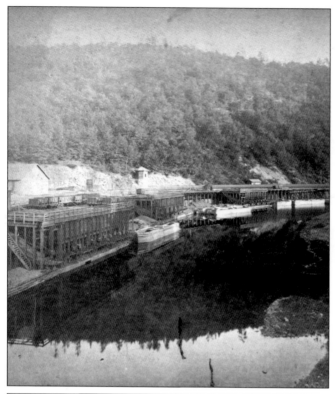

LOADING DOCKS, MAUCH CHUNK. Here are two stereo views of the loading docks along the Lehigh River in Mauch Chunk. The views are from the A. M. Allen and M. A. Kleckner Switchback series. Locomotives brought the coal to the loading docks where it was put in canal boats and shipped to points south. Originally these docks were built here after the floods of 1841 destroyed the docks down stream in Parryville. They were part of the Beaver Meadow Railroad and were used until 1887, when coal was strictly being hauled by the railroads. This area is where the Jim Thorpe Market is located today.

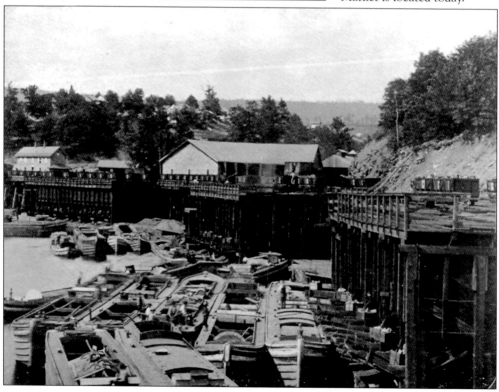

COAL CHUTE NO 1.
The chute along the Lehigh River was completed in 1827. The coal cars from the mines in Summit Hill reached their destination at the chutes in Mauch Chunk. The planes here were double tracked, and while a loaded car descended the plane, the weight of that car pulled an empty one up where it was then returned to the mines.

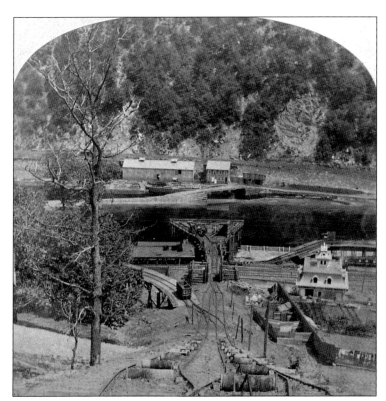

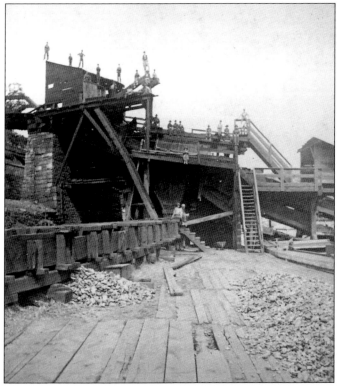

SLATE PICKERS AND THE CHUTES. The coal that came from the mines was never completely devoid of slate, so the Lehigh Coal and Navigation Company used slate pickers at the chutes before the coal was loaded onto barges. Here the workers pose for a picture by Kleckner. The chutes were torn down in 1872 after completion of tunnel No. 7.

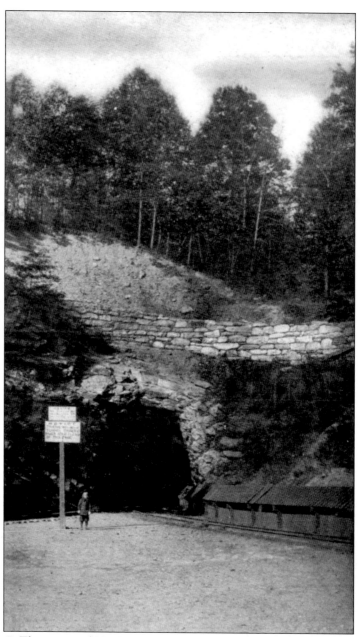

TUNNEL NO. 7. This is tunnel No. 7 in Lansford, which was later known as the Nesquehoning Tunnel, and with its completion, the Switchback was no longer a coal-hauling railroad. No. 7 was first driven in the 1840s into Locust Mountain, and it was in 1869 that work began to open the mine shaft through the mountain from both sides, which connected the Panther Creek valley to the Nesquehoning Railroad in Hauto. The shaft was already 1,400 feet into the mountain and only had to be widened, so time was saved using the mine. Work on the Hauto side was arduous since most of this area was soft clay, and the material collapsed around any digging that was accomplished that day. A large arch was built, and it prevented any more slides. It was in September 1871 that both sides met deep in the mountain. Four months later on January 23, 1872, the Nesquehoning Tunnel was officially opened.

Nine

SPORTS, MISCELLANEOUS, AND LATE ADDITIONS

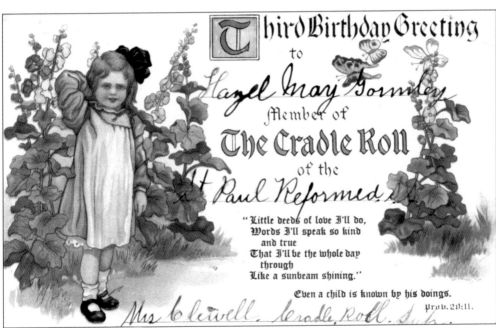

ST. PAUL'S REFORMED SUNDAY SCHOOL. While the German Reformed church was being run by Rev. Charles Freeman, the church Sunday school addition was built. The school was then arranged into grades, and a school board was organized to run the ever-growing Sunday school. Anthony Storch was superintendent of the school for almost 54 years.

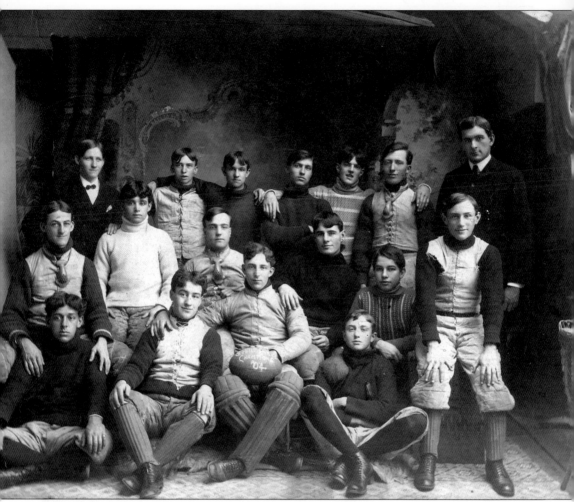

SPARKS FOOTBALL, 1904. Football at the dawn of the 20th century had no forward passes, receivers, or special teams. It was all running and blocking, and the biggest guy always carried the ball. Each player was on his own to find a uniform and his own gear to play. Some of the players used shin guards from the game of cricket. The Summit Hill Sharks were organized by Dr. James Forrest, while Eddie "Buffalo" O'Donnell was the manager. The team was a member of the Carbon County League and won the championship several times, including this team from 1904. Pictured from left to right are (first row) Willie Meyers, William "Boodle" O'Donnell, Harry Houser, and George Rose; (second row) Warren McCready, Albert Christman, Pud Cunningham, Ed O'Donnell, Jim Garrett, and Sam Gluch; (third row) James Forrest, Dick Black, Tom Williams, Harry McMichael, Dan Bynon, Dave Davis, and Eddie O'Donnell.

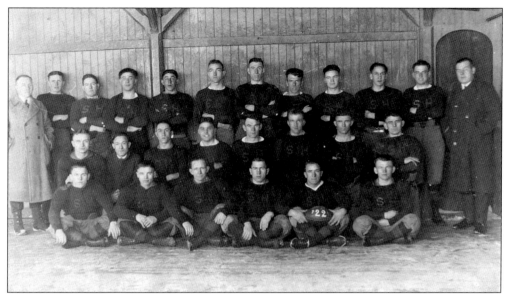

TIGERS FOOTBALL, 1922. This semiprofessional team was also organized by Forrest, who was not only the coach but also the team doctor. The team was in the Carbon-Schuylkill League and played against other towns such as Tamaqua, Coaldale, Lansford, Nesquehoning, McAdoo, Mount Carmel, Minersville, and Mahanoy City.

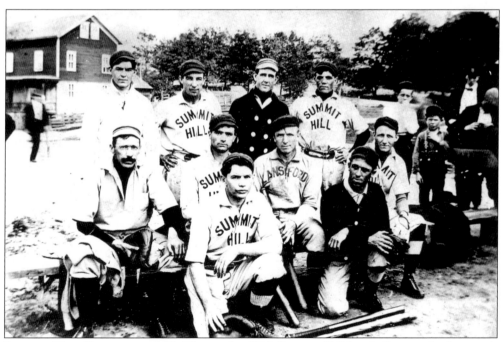

SUMMIT HILL BASEBALL, 1908. This is the 1908 Summit Hill baseball team. In front with the catchers mitt is Connie Melley. Also pictured from left to right are (first row) Joe Gormley, Michael McFadden, Paddy Bonner, Roger Haldeman, and James Forrest; (second row) Eddie McCullion, Pat Conahan, Eddie McDermott, and Leonard Houser. Every town and colliery had its own baseball team, so many of the players seen here played on more than one team.

111

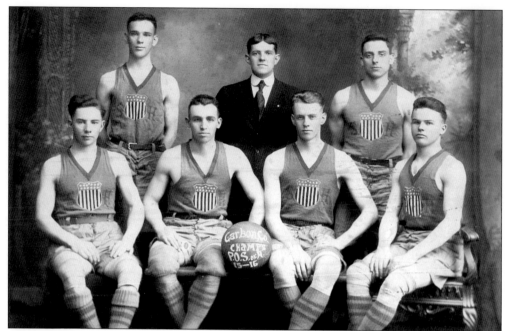

PATRIOTIC ORDER SONS OF AMERICA BASKETBALL, 1915. The Patriotic Order Sons of America had a basketball team that was the Carbon County champions in the 1915–1916 season. Pictured from left to right are (first row) Harry Pflum, unidentified, William Richards, and Bill Black; (second row) Ben Garrett, coach Dan Bynon, and Daniel Stoudt.

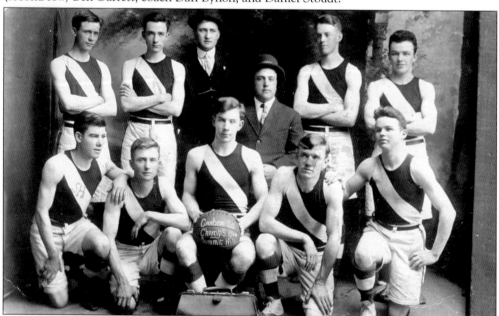

SEMIPROFESSIONAL LEAGUE, 1914. This is the 1914 Carbon County champions from the semiprofessional league. The team played its home games in the Eagle Hotel. Pictured from left to right are (first row) James Campbell, George Rose, Harry Pflum, Jack Aiken, and Bill Black; (second row) Bill Kennedy, Donald Bachert, hotel owner George Kershner, manager Pud Cunningham, Bill Richards, and George Black.

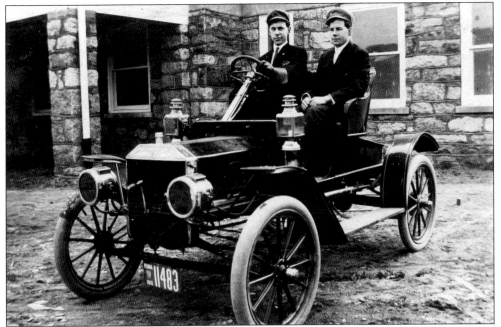

THE FIRST AUTOMOBILE. This photograph, dated 1909, shows the first automobile in Summit Hill. The car appears to be a 1908 Ford Model R, where the passenger, who is unidentified, sits on the left, and the driver, Balsen Fink, is on the right. At this time, there were only about 8,000 cars on the road.

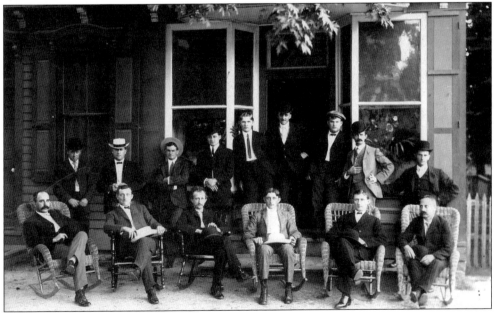

SUMMIT HILL SOCIAL CLUB. This social club was located on the corner of Front and Market Streets. The men later moved to a building across from the Presbyterian church. Pictured from left to right are (first row) Eddie James, Eddie Evans, Will Arner, Walter Evans, Dalt Evans, and Frank Arner; (second row) unidentified, Kennedy, O'Donnell, Jack Leslie, ? Walker, ? Miller, Squire Cunningham, Jim Gormley, and Westy Hontz.

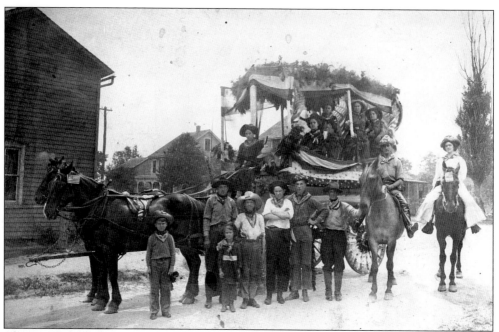

PARADE FLOAT. This 1910 photograph shows a float from one of the many parades held throughout the year. The couple on the horses is John Aubrey and Dolores Bacon. One of the women in the wagon is Millie Houser. Other people in the picture are George Aubrey, Dillie Foulk, Harry Pflum, and Frances Kleckner.

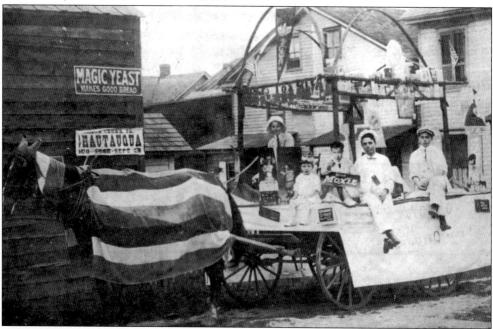

WILLY ROSE'S GROCERY. Another parade float, this one from 1915, is on Willy Rose's grocery wagon. The picture was taken at the rear of the Rose house on East Fell Street. Gilbert Rose is holding the reigns; Willy Rose is sitting next to the Moxie sign, his young son Hayden is on the left, and his brother Charlie is on the right.

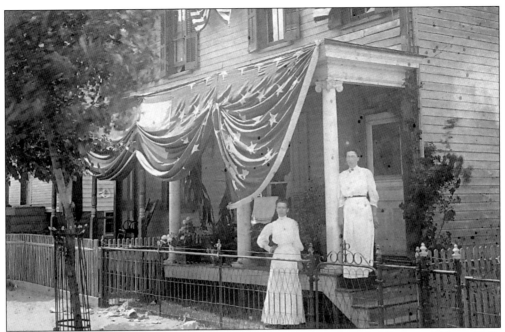

DAWN OF THE 20TH CENTURY. This is a picture with an unidentified homestead beautifully decorated with patriotic banners. Summit Hill had 2,000 residents living in town in 1900. Life was relatively simple. There were no movies or radios. A maintenance man was hired for $1.15 a day to keep the streets in order and sewers repaired.

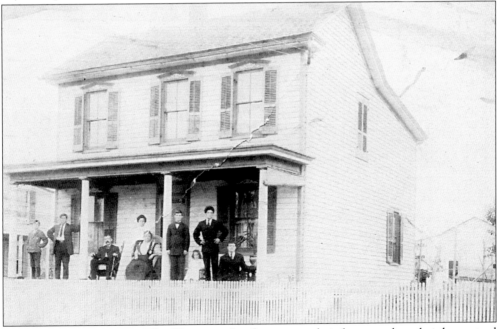

CHRISTMAN HOMESTEAD. The Christman family poses on their front porch at their homestead located on East Walter Street at the end of Oak Street. Around 1900, a board of health was created to maintain sanitary conditions, list any outbreaks of contagious diseases, record births and deaths, and inspect the slaughterhouses.

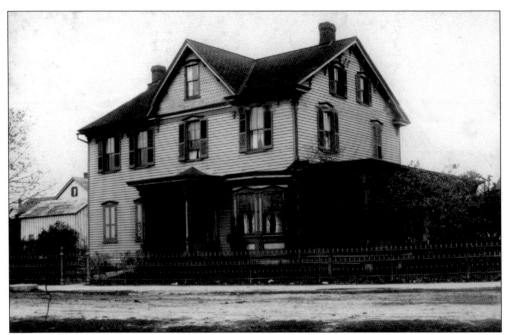

LEHIGH COAL AND NAVIGATION COMPANY EMPLOYEE HOME. In November 1902, the company posted pictures of houses that employees owned to show how good life could be for those that worked for them. This is the home on West Front Street next to the armory. The company rented houses for $3.75 a month if workers could not afford to own one.

FELL STREET HOUSES. Here are more employee-owned houses on Fell Street in 1902. At that time, coal cost almost $3 a ton. A miner received $1 for working a 10-hour workday. Children often started working at young ages to help with the family income. Boys around the age of 10 got 25¢ a day, and young girls became maids for the more affluent residents.

WEST HOLLAND STREET HOMES. These homes were across from the old armory. Summit Hill had some short-lived newspapers in the 1870s. The *Weekly Intelligencer* lasted for two years from 1873 to 1875. It was published by Daniel Eveland and Robert Harris. The *Summit Hill Independent* was only published for six months in 1876.

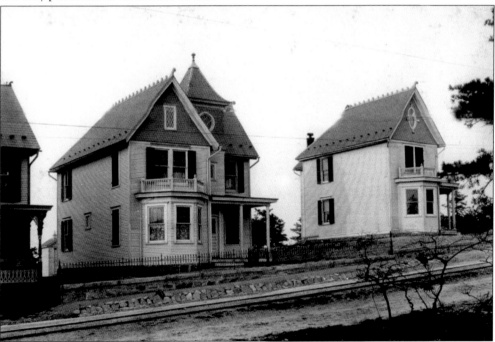

EAST WHITE STREET HOMES. The houses pictured here are on East White Street above Pine Street. The company did all kinds of promoting of their jobs and the success of their employees, saying they took care of their employees and paid them well.

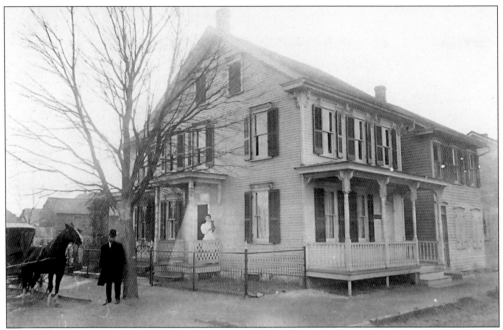

HOMES ON CHESTNUT AND WHITE STREETS. These were the homes of M. A. Pondtz and Alexander Houser in 1904. It was in 1890 that the Pennsylvania Globe Gaslight Company installed the first streetlights. Seven years later, phone lines were installed in town, but it took some time before people bought any.

EAST FRONT STREET, 1911. This house along the Switchback Gravity Railroad tracks by Oak Street is pictured on this postcard sent in 1911. Some of the ordinances of the times seem odd by today's standards. Horses and bicycles had a speed limit of six miles per hour. Livestock running free were penned up on a lot by the Lutheran church, and dogs were shot.

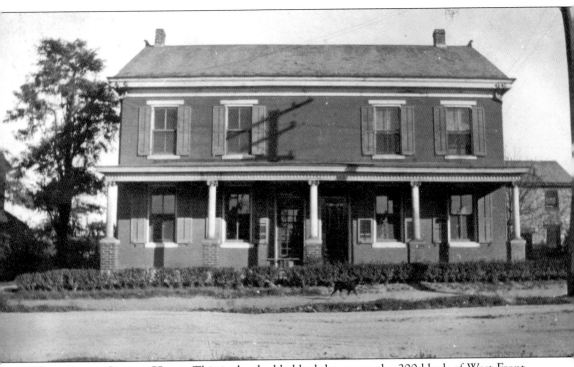

WEST FRONT STREET HOME. This is the double-block house on the 200 block of West Front Street. Built in the 1860s by Samuel Allen, this was where Dr. Michael Thompson ran his office. He was a native of England and moved to Pennsylvania when his father was young. He was first a mechanic then decided to study medicine at Jefferson Medical College, graduating in 1861. He entered the army as an assistant surgeon that year. After resigning his commission, he came to Summit Hill on June 25, 1863, and ran an extensive practice. According to his tax statement from 1867, Thompson grossed nearly $2,200. He ran his practice until 1876, when he became sick and passed away. The first physician to move into the area was Dr. Benjamin McConnell. Around 1824, he was the physician for the Lehigh Coal and Navigation Company in Mauch Chunk. In 1840, he moved to Summit Hill, where he ran his practice until he died in 1861.

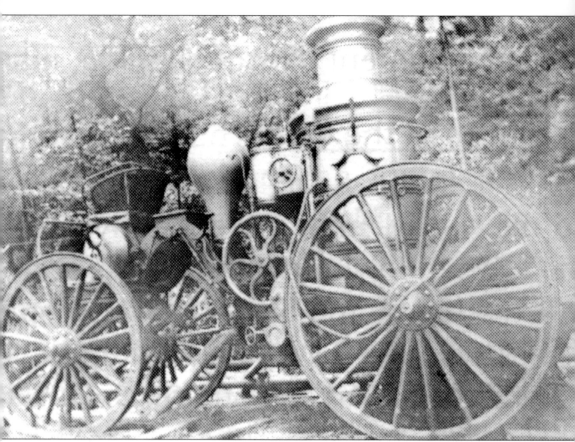

DILIGENCE FIRE COMPANY. In 1889, a small group of men met with Burgess Joseph Richards and drew up plans for a fire department. The men at the meeting were Cornelius Boyle, Edward Boyd, T. J. Campbell, John Boyle, F. X. Cannon, J. B. Cunningham, John Fink, Charles Ingersoll, John McMichael, Charles Minnick, E. E. Scott, and William Schneider. It took many years, but on October 11, 1897, the Diligence Fire Company No. 1 received its charter. In addition to the men at the first meeting, 26 other names were listed as charter members. In 1899, the town council purchased a horse-drawn steamer, carriage, hose, and any other needed materials. The town transferred the items "to the custody and care of the fire company in trust for the borough of Summit Hill." Frank Arner was the first engineer of the fire company.

FIREFIGHTERS, 1912. This picture, taken at old home week in 1912, shows some of the men who were members of the fire department. Pictured from left to right are Dick Jones, Eddie James, Tom Johnson, Dr. James Forrest, Red Ronemus, John McGinley, Mike O'Donnell, Roger Jones, Harry Houser, Bennie Pollack, Joe O'Donnell, Jim O'Donnell, Dr. James Dougherty, E. V. McCullion, Kid Watkins, Herbie McMichael, Robert Scott, Pete Boyle, Michael Bonner, George Kershner, and Will Haughton.

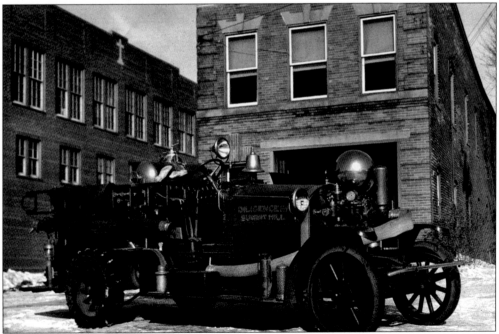

AHRENS-FOX PUMPER, 1945. This is the 1915 Ahrens-Fox pumper, which was the first motorized fire truck the department purchased. At the time, Ahrens-Fox was based in Cincinnati, Ohio, and was the third-largest manufacturer of fire trucks in the United States. When this picture was taken in 1945, the pumper was being replaced with a Mack truck pumper.

MILITARY UNIT. What appears to be a military unit poses for a picture on Holland and Chestnut Streets. The most unfortunate aspect of many pictures is that there are no names or dates listed, leaving one to guess the nature of their business and who they are.

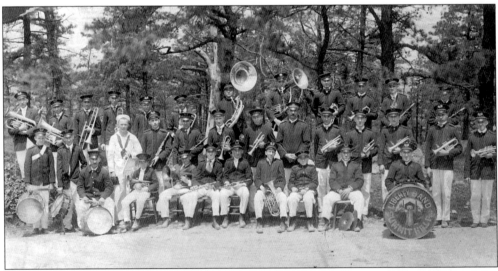

SUMMIT HILL LIBERTY BAND. Pictured from left to right are (first row) Harry Miller, John Mollard, Van Horn, Randy Davis, Lorenz Arner, Stanley Mollard, Latzie Peltz, Eddie Rex, and George Lager. The second row includes ? McLaughlin, Jimmy Newton, Jimmy Hough, Lester Black, John Mollard (director), Emanuel Ross, ? Humphrey, ? Troxell, John Mollard Jr., and ? Whildin. Included in the third row are Jap Evans, ? Shires, Gordon Stewart, John McHugh, Red Ackerman, Bill Sittler, Stanley Henninger, Tom Evans, Gilbert Rose, and ? Stewart.

JACK BONNER. Born in 1874, Jack Bonner was the oldest of three boxing brothers who were slate pickers in the mines at an early age. He fought in the middleweight class in the 1890s but was not afraid to box with someone from the light-heavyweight class. Bonner faced Kid McCoy in 1897 and Tommy Ryan in 1898 while they were holding the middleweight championship.

NOAH'S ARK. This Noah's Ark Ice Cream Boat, pictured in 1941, was located at the top of the White Bear hill on Amidon Street. The stand featured a monkey and a giraffe on the roof and had an anchor on the side. Mr. and Mrs. Edwin Rex also had a free playground area behind the boat. It was later sold to a merchant who used it at the Lehighton fair for years.

CAPITOL THEATER. Dr. Thomas Davis built the Capitol Theater in the 1920s as a movie theater. This picture was taken in 1948 when the theater featured the movie *Scudda Hoo! Scudda Hay!* A little-known fact about this movie is that it is considered the screen debut of Marilyn Monroe, even though most of her scenes were cut.

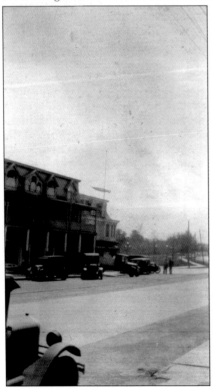

MAY 1929. This picture was taken in May 1929 when the Graf Zeppelin *Los Angeles* was flying over Summit Hill, as seen by the flagpole in the picture. The airship was given to the United States by Germany in 1924 and was commissioned by the U.S. Navy in November. The Graf Zeppelin logged over 4,000 hours of flight in 15 years of service.

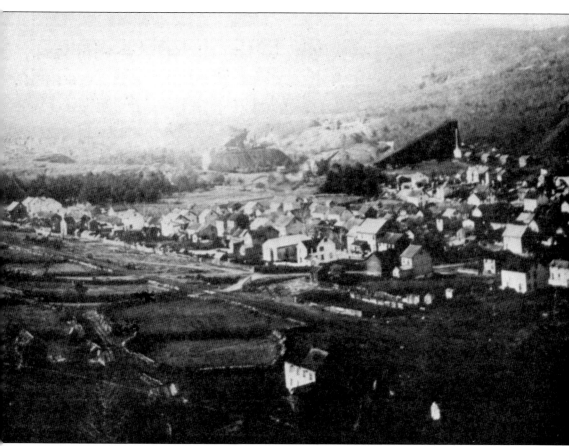

LANSFORD. In the 1820s, there were but a few scattered cabins, and this area was known as Ashton. The settlement on the west side of Ashton was known as Storm Hill. As the mining industry grew, so did Ashton. The biggest boost to the town was when the Nesquehoning Tunnel was completed in 1872, and the company moved all the offices and repair shops from Summit Hill to Ashton. On July 1, 1876, the community was incorporated as a borough and changed its name to Lansford. The name came from Asa Lansford Foster, a prominent developer of the mining industry in the Panther Creek valley. In fact, he drove one of the first mine shafts by the old mine, named Foster's Tunnel. The population grew dramatically, from a little over 2,200 to a bustling 9,600 in 1920.

WATER ST. COAL DALE, PA.

COALDALE. The first inhabitant of Coaldale (Coal Dale) was John Moser, who built a house in the area of what was later Manilla Grove. For years, Coaldale and the villages of Seek were part of Rahn Township. Some of the villages included Bull Run, which is the area around the Coaldale Hospital, and Gearytown, which lies west of Bull Run in the area of Miner and Greenwood Streets. In 1864, the first houses were built in the village of Bugtown, which is the area southeast of the Coaldale Hospital. Centerville, also known as Skintown, was on the south side of Coaldale but was later abandoned because the area was undermined. The area of New Wales on the west side of town had the first houses built in 1849. From all these little villages, the town was organized as the borough of Coaldale in June 1906. The town's first burgess was Dr. C. C. Gallagher, and a town hall was constructed a year later.

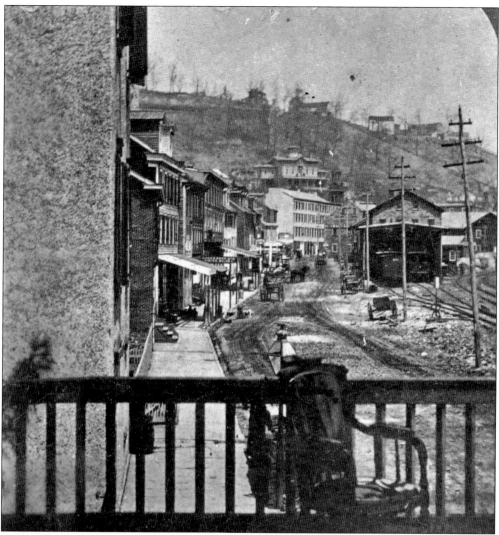

MAUCH CHUNK, 1870S. This 1870s view of Susquehanna Street from the porch of the Mansion House Hotel in old Mauch Chunk shows the Asa Packer mansion and the old courthouse building. The Mansion House Hotel and other businesses on Susquehanna Street relied on the bridge that connected the street to the Lehigh Valley Railroad station on the other side of the Lehigh River. Early maps have the area listed as Coalville. It grew rapidly in the 1820s, as a result of the success of the Lehigh Coal and Navigation Company. Mauch Chunk was assigned as county seat of the newly formed Carbon County in 1843. Seven years later, the town was incorporated and was the first borough of Carbon County. On July 15, 1849, about 30 buildings in the business district of Mauch Chunk burned down, including the courthouse, jail, and the offices of two newspapers, the *Lehigh Pioneer* and the *Mauch Chunk Courier*. The fire began on Race Street and the resulting damage totaled $150,000.

www.arcadiapublishing.com

Discover books about the town where you grew up, the cities where your friends and families live, the town where your parents met, or even that retirement spot you've been dreaming about. Our Web site provides history lovers with exclusive deals, advanced notification about new titles, e-mail alerts of author events, and much more.

MADE IN THE USA

Arcadia Publishing, the leading local history publisher in the United States, is committed to making history accessible and meaningful through publishing books that celebrate and preserve the heritage of America's people and places. Consistent with our mission to preserve history on a local level, this book was printed in South Carolina on American-made paper and manufactured entirely in the United States.

This book carries the accredited Forest Stewardship Council (FSC) label and is printed on 100 percent FSC-certified paper. Products carrying the FSC label are independently certified to assure consumers that they come from forests that are managed to meet the social, economic, and ecological needs of present and future generations.

FSC
Mixed Sources
Product group from well-managed forests and other controlled sources

Cert no. SW-COC-001530
www.fsc.org
© 1996 Forest Stewardship Council

Find Your Place in History.